IMAGES
of America

US LIFE-SAVING SERVICE
FLORIDA'S EAST COAST

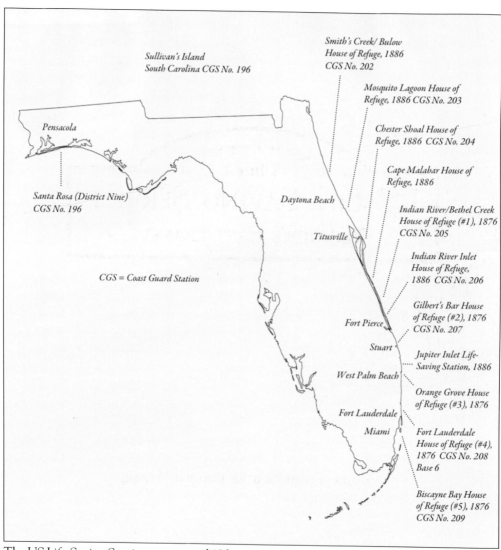

Sullivan's Island
South Carolina CGS No. 196

Smith's Creek/ Bulow
House of Refuge, 1886
CGS No. 202

Mosquito Lagoon House of
Refuge, 1886 CGS No. 203

Pensacola

Chester Shoal House of
Refuge, 1886 CGS No. 204

Cape Malabar House of
Refuge, 1886

Santa Rosa (District Nine)
CGS No. 196

Daytona Beach

Indian River/Bethel Creek
House of Refuge (#1), 1876
CGS No. 205

Titusville

Indian River Inlet
House of Refuge,
1886 CGS No. 206

CGS = Coast Guard Station

Gilbert's Bar House
of Refuge (#2), 1876
CGS No. 207

Fort Pierce

Stuart

Jupiter Inlet Life-
Saving Station, 1886

West Palm Beach

Orange Grove House
of Refuge (#3), 1876

Fort Lauderdale

Miami

Fort Lauderdale
House of Refuge (#4),
1876 CGS No. 208
Base 6

Biscayne Bay House
of Refuge (#5), 1876
CGS No. 209

The US Life-Saving Service constructed 10 houses of refuge, unique to Florida, between 1876 and 1886. Florida's Jupiter Inlet Life-Saving Station and the South Carolina's Sullivan's Island Life-Saving Station were in the same district as the houses of refuge. Santa Rosa Island Life-Saving Station near Pensacola, although in a different district, is included in this book because it was the only other US Life-Saving Station in Florida. With the creation of the US Coast Guard in 1915, the former US Life-Saving Service structures became Coast Guard stations. (Deanna Thurlow.)

ON THE COVER: The former Mosquito Lagoon House of Refuge, in the background, was US Coast Guard Station No. 203 when this photograph was taken in 1934. Following World War II, the building was decommissioned, vandalized, and destroyed by fire. Today, the site is within the Canaveral National Seashore. (National Archives.)

IMAGES
of America
US LIFE-SAVING SERVICE
FLORIDA'S EAST COAST

Sandra Thurlow and Timothy Dring

To Vic,
A great friend
and sailing companion.
All my best.
Tim
Feb 2018

ARCADIA
PUBLISHING

Published by Arcadia Publishing
Charleston, South Carolina

Printed in the United States of America

Library of Congress Control Number: 2016949527

For all general information, please contact Arcadia Publishing:
Telephone 843-853-2070
Fax 843-853-0044
E-mail sales@arcadiapublishing.com
For customer service and orders:
Toll-Free 1-888-313-2665

Visit us on the Internet at www.arcadiapublishing.com

This book is dedicated to the men and women of the US Coast
Guard and their US Life-Saving Service forebears who have kept
the Florida coast safe for all Americans and seafarers alike.

CONTENTS

ACKNOWLEDGMENTS

The authors wish to acknowledge the assistance and generosity of the following individuals and organizations, without whom a comprehensive historical work of this type would not have been possible: Candace Clifford, James Claflin, Seth Bramson, Alice Luckhardt, Colleen Kimball, Jeff Shook, Marjorie Nelson, Cisco Deen, David Childs, Scott Price (chief historian, US Coast Guard), Pam Cooper (Florida history/genealogy librarian, Indian River County Library), Debi Murray (chief curator, Historical Society of Palm Beach County), Josh Liller (educational curator, Jupiter Inlet Lighthouse and Museum), Linda Geary (keeper, Gilbert House of Refuge Museum), Jennifer Esler (president/CEO, Historical Society of Martin County, Elliott Museum/Gilbert's Bar House of Refuge Museum), Mary Walton Jones (executive director, Stuart Heritage Museum), Todd Bothel (supervising curator, Fort Lauderdale Historical Society), Ruth McSween (curator, National Navy UDT-Seal Museum), Michael Boonstra (archivist, Brevard Historical Commission), and Susan Sandness (North Miami Beach Library).

The names of over 30 individuals who supplied photographs appear in the credit spaces.

We are grateful to Jim McCormick, former keeper of Gilbert's Bar House of Refuge Museum, who suggested publishing this book; and at Arcadia, Emilia Monell, acquisitions editor, who accepted the proposal and began the process, and Liz Gurley, senior title manager, who carried the book through to fruition.

Arcadia Publishing's Images of America books reach readers with an interest in local history in a way academic publications seldom do. The authors hope this book, focusing on Florida and made possible by the contributions of many, will make this important part of the state's history more widely appreciated. Other authors who have researched Florida houses of refuge include Stephen Harry Kerber, *The United States Life-Saving Service and the Florida Houses of Refuge*, unpublished master's thesis, Florida Atlantic University, 1971; Jennifer McKinnon, *The Archaeology of Florida's US Life-Saving Service Houses of Refuge and Life-Saving Stations*, unpublished PhD dissertation, Florida State University, 2010; and Ralph and Lisa Shanks and Wick York, *The U.S. Life-Saving Service, Heroes, Rescues and Architecture of the Early Coast Guard*, published in 1996 by Costaña Press, which is a very thorough review of all life-saving stations and includes a chapter entitled "Houses of Refuge and Life-Saving Stations of Florida."

INTRODUCTION

Ten houses of refuge were constructed along Florida's east coast as part of the US Life-Saving Service. Five were built in 1876, and five more constructed in 1886. They were unique to Florida, where shipwreck victims were far from civilization and help of any kind. The houses of refuge served many other purposes, but, above all, they were a governmental toehold in a wilderness that paved the way for the development of Florida's east coast. Few people today even know the houses of refuge ever existed. Almost no one understands the important role the US Life-Saving Service played in Florida's pioneer history.

The US Life-Saving Service came into being through a series of government enactments dating back to 1848. For decades, it was fragmented, underfunded, and inefficient. The cost in lives and property lost in shipwrecks was staggering.

In 1871, a young lawyer from Maine who was working in the US Treasury Department as a clerk had proven to be such a gifted leader and administrator that he was appointed chief of the Revenue Marine Bureau. His name was Sumner Increase Kimball, and he would become the father of the then modernized US Life-Saving Service. When Kimball assumed the reigns of the Revenue Marine Bureau, the life-saving service was within the bureau and was his responsibility. The previously dysfunctional life-saving service needed to be completely overhauled.

Congress had previously been funding strictly volunteer life-saving stations, paying only for the buildings and equipment. Kimball convinced Congress to pay for fully trained crews under the direction of appointed keepers with modernized stations and equipment. He weeded out the ineffective and those who were taking advantage of the system. New life-saving stations were constructed around the country and were equipped with the finest equipment available.

The US Life-Saving Service remained within the Revenue Marine Bureau until 1878, but historians consider 1871, the year of Kimball's appointment, its real beginning. Because of Sumner Kimball's success, Congress separated the US Life-Saving Service from the Revenue Marine Bureau in 1878 and made it an autonomous organization. When Pres. Rutherford B. Hayes nominated Sumner Kimball as general superintendent, he was unanimously confirmed and remained in charge of the US Life-Saving Service for its entire existence. Kimball knew the US Life-Saving Service presence on Florida's east coast had to be tailored to fit local conditions. Although the climate was normally mild, ships using the Gulf Stream sometimes encountered violent storms and were grounded or blown onto reefs. Luckily, after storms passed, conditions moderated; however, shipwreck victims needed help to survive. Shipwreck survivors who reached the then uninhabited shore faced death from hunger, thirst, and exposure.

The east coast of Florida was sparsely populated. According to Lillie Pierce Voss, who was born at the Orange Grove House of Refuge in 1876, south Florida was "a howling wilderness." The US Census of 1880 enumerated 40 single men and 29 families with children in Dade County. At the time, Dade County reached all the way up to the St. Lucie River and included four of the first five houses of refuge. Obviously, there were not enough men to establish fully manned life-saving stations with crews. So rather than life-saving stations with crews, Florida had houses of refuge manned by only a keeper and his family if he was lucky enough to have a family.

Kimball divided the United States into 11 districts and appointed a superintendent for each one. These men had to be highly qualified and of good character and had to live in the districts they supervised. Kimball realized the success of the organization was on their shoulders. At his request, an officer of the US Revenue Cutter Service, headquartered in New York City, acted as inspector for the US Life-Saving Service.

District superintendents and inspectors visited each station or house of refuge at least quarterly and sent reports to Kimball. Keepers were required to keep daily logs with weekly transcripts sent though the district superintendents to the general superintendent. Keepers also submitted reports whenever there was a shipwreck. All of the reports, significant letters, and articles about every aspect of the US Life-Saving Service were compiled, analyzed, and published annually beginning in 1876. These annual reports listed shipwrecks by name with figures, including number of lives lost and amount of cargoes salvaged. They listed facilities, salaries, awards, and equipment. Each *US Life-Saving Service Annual Report* is a time capsule of service history.

The first annual report states: "The outer coast of Florida is almost unbroken, and borders a waste and desolate region for the distance of nearly five hundred miles. It is closely approached by all vessels passing between the Gulf of Mexico and the Atlantic States. At certain seasons it is visited by heavy gales and tornadoes, by which vessels are frequently thrown upon its inhospitable shores. Escape from the wrecks to the land by those on board is usually possible, but frequently they find themselves delivered from the perils of the sea only to encounter on the land the probability of death by starvation and thirst."

In this report, Florida's first five houses of refuge are listed by location, with the names of their original keepers under William H. Hunt of Biscayne, Florida, as superintendent of District 7.

By 1886, five more houses of refuge stood on Florida's east coast, as well as a life-saving station at Jupiter Inlet. Charleston Harbor, in South Carolina, was put in the same district as the east coast of Florida. Morris Island Life-Saving Station, near Charleston Harbor, was constructed at the same time Santa Rosa Island Life-Saving Station was built near Pensacola, Florida. Although it was in a different district, Santa Rosa Island Life-Saving Station is included in this book simply because it was the only US Life-Saving Service facility in Florida other than those on the East Coast.

By the end of the US Life-Saving era in 1915, there were 13 districts. District 7, including Florida's east coast, was changed to District 8 in 1901. Santa Rosa Island Life-Saving Station then fell within District 9.

This book includes rare photographs that are available for the first five houses of refuge, beginning with House of Refuge No. 1, first named Indian River and later named Bethel Creek, and going down Florida's east coast to No. 5, Biscayne Bay House of Refuge. These will be followed by photographs of the second five houses of refuge, starting with the northernmost, Smith's Creek House of Refuge, later called Bulow, to Indian River Inlet House of Refuge, just north of Fort Pierce. The three life-saving stations will follow.

After the stories of the houses of refuge and life-saving stations, this book continues to cover the houses of refuge and two life-saving stations after 1915, when they became Coast Guard stations. All of the former locations are now public places of significance. Only one house of refuge, now Gilbert's Bar House of Refuge Museum in Martin County, remains standing.

The last two chapters of this book feature photographs shared by two families. The Coutant family contributed photographs taken when Samuel Coutant was keeper of the Mosquito Lagoon House of Refuge. Susan Hall Johnson and her daughter Jennifer Johnson Strauss supplied photographs taken at US Coast Guard Station No. 207, the former Gilbert's Bar House of Refuge, during World War I.

Although mountains of paper—documents and reports of every type pertaining to the US Life-Saving Service and early Coast Guard—have been preserved, there are very few photographs. For example, there are no known photographs of the Cape Malabar House of Refuge, which was in service from 1886 to 1891. Each image in this book is precious because it conveys information and understanding that goes beyond words.

One

FLORIDA'S ADAPTATION OF US LIFE-SAVING SERVICE STATIONS

Houses of refuge were unique to Florida. Lacking the usual station crew of surfmen, keepers of houses of refuge were primarily responsible for providing shelter, food, and clothing to victims of shipwrecks. They were also required to help survivors find transportation back to civilization. Before Henry Flagler's railroad reached Miami in 1896, shipwreck victims had to be transported many miles to the nearest railhead by sailboat.

Although their duties were usually uneventful, a house of refuge keeper's life was sometimes punctuated with high tension and drama in the event of a shipwreck. After the death of District 7 superintendent William Hunt in 1882, Champlin H. Spencer became district superintendent. The 1883 annual report announced contracts for five additional houses of refuge in Florida and plans for fully staffed life-saving stations on Morris Island near Charleston, South Carolina, and at Jupiter Inlet in Florida.

By 1886, the new District 7 superintendent, Frank W. Sams, had 10 houses of refuge and two life-saving stations to supervise. Although separated by many miles, Morris Island Life-Saving Station was put in District 7 with Florida's east coast facilities. Through the years, crew members from South Carolina served in Florida and men who initially served in Florida were assigned to South Carolina.

At the same time new stations were added to District 7, Santa Rosa Island Life-Saving Station was constructed in Florida's Panhandle in District 8. After the main shipping channel in Charleston Harbor was changed, the Morris Island station was too remote, so a new life-saving station was constructed on Sullivan's Island, South Carolina, in 1895.

By 1900, general superintendent Sumner Kimball was reporting on the difficulty of attracting the brightest and best men as keepers and surfmen. Times were changing, and the young leaders who grew up on the Great Lakes or ocean and who were natural recruits for the US Life-Saving Service were enticed to better employment in the cities.

Some houses of refuge, as well as the Jupiter Inlet Life-Saving Station, were closed before the US Coast Guard was created in 1915. Cape Malabar House of Refuge was discontinued in 1891, Orange Grove House of Refuge was closed in 1896, and the Jupiter Inlet Life-Saving Station was closed in 1899.

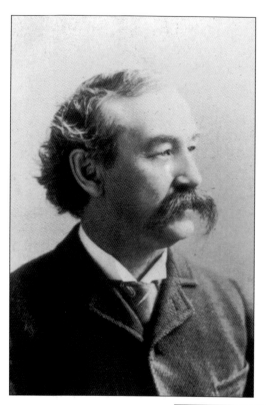

Sumner Increase Kimball was responsible for the US Life-Saving Service from its inception in 1871, when it was part of the Revenue Marine Bureau/Revenue Cutter Service within the Treasury Department, and it became an independent service away from the Revenue Marine/Revenue Cutter Service (but still under the Treasury Department) in 1878. He was appointed superintendent in 1878 and remained in the position until the merger of the US Life-Saving Service and the US Revenue Cutter Service in 1915, which created the US Coast Guard. Born in Maine in 1834, he graduated from Bowdoin College in 1855. Three years later, he was both married and admitted to the bar. Kimball then moved to Washington, DC, where he worked as a clerk in the Treasury Department. In 1871, he was appointed to head the Revenue Marine Bureau. By that time, life-saving stations, for which the bureau was responsible, had become ineffective. Establishing and overseeing the new US Life-Saving Service became Kimball's life work. (National Archives.)

The US Life-Saving Service was a typical but effective bureaucracy, with a hierarchy of districts, district superintendents, assistant district superintendents, and inspectors. Florida's houses of refuge were originally in District 7, but the district became District 8 in 1901. The written records of the US Life-Saving Service are voluminous, but photographs of its station personnel are rare. This letter from William H. Hunt, who took over as superintendent of District 7 as soon as the first five Houses of Refuge were constructed in 1876, is on official US Life-Saving Service stationery with the post office address of "Biscayne, Fla." (National Archives.)

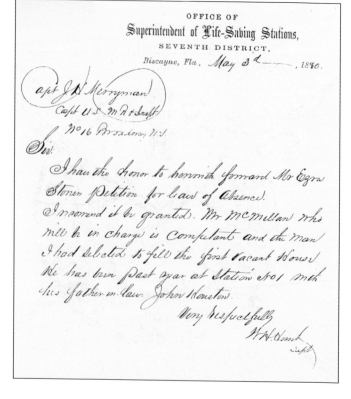

William H. Gleason was the first person to take the reins of what would become District 7 of the US Life-Saving Service but was quickly replaced by his colleague William H. Hunt. The two men arrived at Biscayne Bay with their families in 1866. Gleason, a Yale-educated attorney and engineer, had already had a colorful opportunistic career before deciding that Florida was the land of opportunity. His appointment by Sumner Kimball to locate the first five houses of refuge was just one of many governmental positions he filled. Previously, in 1868, his election as the lieutenant governor of Florida was nullified, as well as his attempt to be Florida's governor. (Florida Archives.)

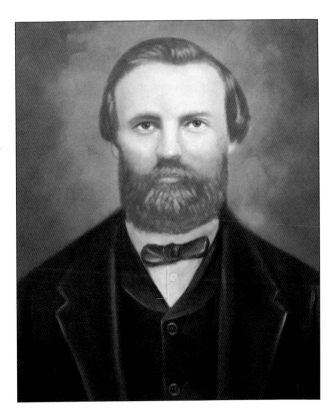

Florida's first five houses of refuge were built in 1876, five years after the US Life-Saving Service was established as an arm of the US Revenue Cutter Service within the US Treasury Department. In 1878, the US Life-Saving Service became an independent branch of the US Treasury Department. (US Coast Guard Historian's Office.)

The US Life-Saving Service exhibited Francis W. Chandler's architectural plans for Florida's new houses of refuge in the huge $80,000 US government pavilion constructed for the Centennial International Exposition in Philadelphia in 1876. This wood engraving from Frank Leslie's Historic Register of the Great Centennial Exposition shows the US Life-Saving Service exhibit, including the life-saving station that was later moved to Cape May Point, New Jersey. (Timothy Dring.)

Keepers of houses of refuge were not expected to perform rescues, but they or members of their family were supposed to walk the beach in search of victims of shipwreck following every storm. In 1881, when there were still only five houses of refuge, signposts placed every mile, beginning 20 miles north of House of Refuge No. 1, were erected showing the distance to the nearest house of refuge. (Sarah Howe Prado.)

Hiram B. Shaw, whose photograph appeared in the *Miami Metropolis* in October 1901, was appointed superintendent of District 7 in 1891. Although his job did not change, District 7 became District 8 in 1901. Shaw's office was in Ormond, Florida, but he was responsible for houses of refuge and two life-saving stations stretching from Biscayne Bay to Sullivan's Island in South Carolina. (National Archives.)

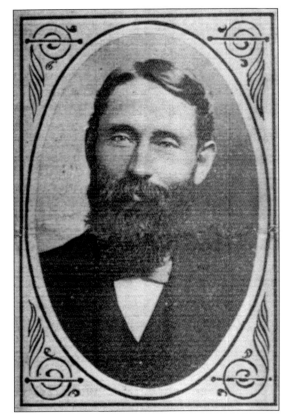

This drawing of Bethel Creek House of Refuge, with the ocean at top, shows the plan of all of the houses. The cistern was on the north side with the kitchen adjoining it. Next were the dining room, living room, and bedroom, in that order. The second floor was used by family members and visitors but had to be ready to receive victims of shipwrecks. (Historical Society of Martin County.)

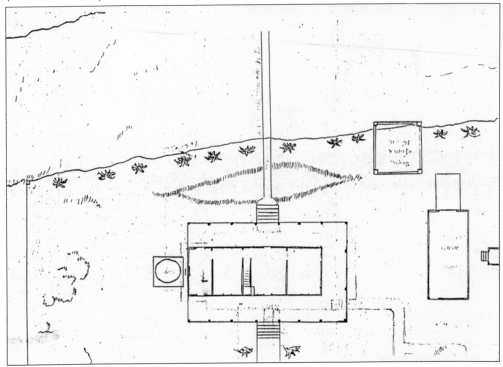

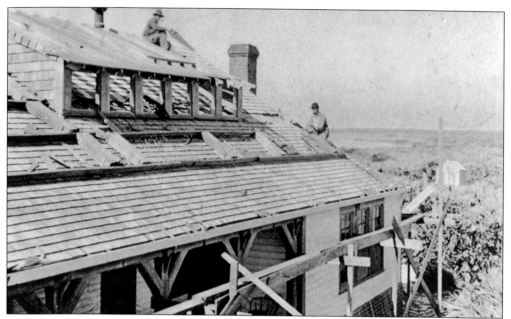

Around 1911, upper-story windows were added to six of the eight remaining houses of refuge. Here, alterations are being made at the Mosquito Lagoon House of Refuge. Only two houses had the same number of windows added: Smith's Creek and Bethel Creek, both of which had nine on each side. The window arrangements for the others were Mosquito Lagoon, six; Fort Lauderdale, eight; Biscayne Bay, 10; and Gilbert's Bar House of Refuge, 12. (Elwin Coutant.)

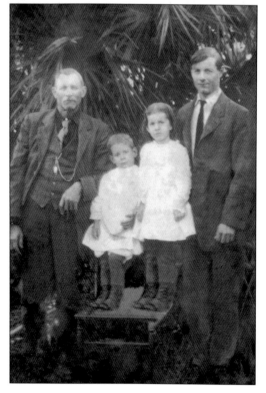

John Carroll Houston (right), the first keeper of Indian River House of Refuge (renamed Bethel Creek House of Refuge in 1886), stands beside his daughter Annie Laura, who was born on January 6, 1878, at the house of refuge. The man at left is John C. Houston III, Annie Laura's grandfather. The younger child is unidentified. (Pat Braddock Youngs.)

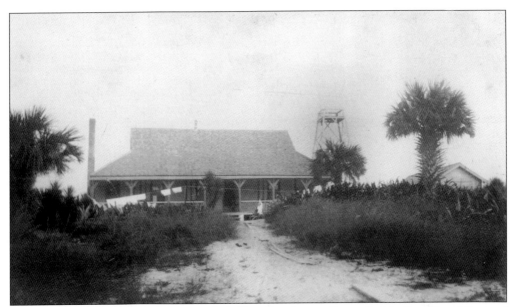

House of Refuge No. 1, located on today's Vero Beach, was first called Indian River House of Refuge and then later renamed Bethel Creek House of Refuge. The name change occurred in 1886, when one of the second series of five houses of refuge was named Indian River Inlet House of Refuge. (Vandiveer Collection, Indian River County Library.)

Annie Laura Houston was born at Indian River House of Refuge when her father, John C. Houston IV, was keeper. Both John and his wife, Susan Stewart Houston, were 38 years old at the time of Annie Laura's birth. Their oldest child, Clara Bell, was 16 years old and had recently married Preston A. McMillan, who would take over John Houston's position of keeper in 1881. (Pat Braddock Youngs.)

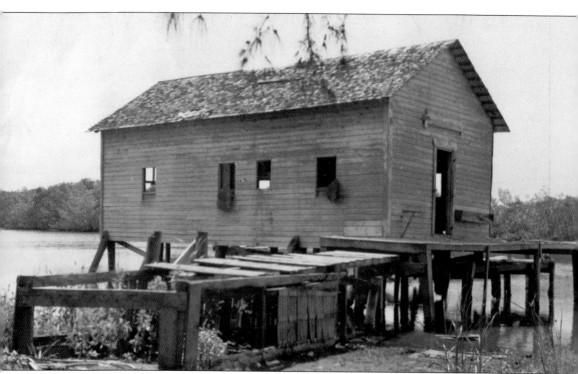

This boathouse on Bethel Creek stored boats used for getting supplies and for going to the post office. However, by 1921, the original Bethel Creek House of Refuge was gone and US Coast Guard Station No. 205 that stood in its place had a truck for hauling supplies. The construction of a bridge across the Indian River in 1920 and roads connecting it to the station eliminated the need for hauling necessities by boat. (National Archives.)

Norwegians Laura and Ludvig Hovelsrud immigrated to Minneapolis, Minnesota, where they were married in 1888. Ludvig was appointed keeper of the Bethel Creek House of Refuge in 1901 after he and Laura moved to Oslo, Florida, with their six children. A seventh child was born in Florida. In 1903, the whole family became ill. All recovered except Ludvig, who died days before his 44th birthday. (Katherine A. Bradley.)

Rachel Hovelsrud poses with her brother Herman, who lost his arm in a shark attack when the family lived at Bethel Creek House of Refuge. The photograph was taken in Miami, where Laura Hovelsrud moved with her seven children after her husband Ludvig's death in 1903. Dr. William Hughlett, the attending physician, said the keeper's death was due to bad drinking water from the wooden cistern. (Katherine A. Bradley.)

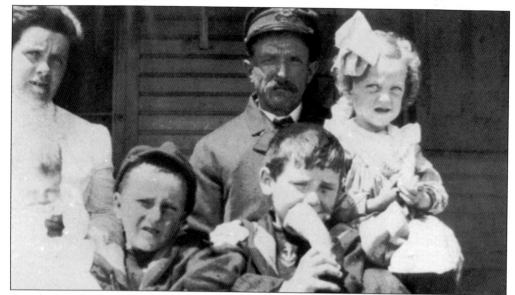

French Canadian Ludger Joseph Gignac was keeper of Bethel Creek House of Refuge from 1904 until 1907. He met his wife, Mary, in Chicago where he was a surfman in the US Life-Saving Service. Mary, at right, holds Arthur, born at Bethel Creek House of Refuge. The other children are, from left to right, Joseph, Ludger Jr., and Philomene. Another daughter, Delphine, was born February 28, 1907. (Wilson Price)

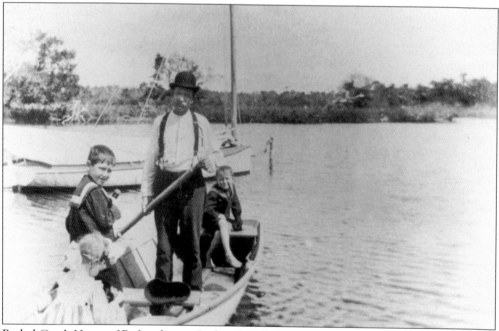

Bethel Creek House of Refuge keeper Ludger Joseph Gignac takes his three older children for a boat ride near the house of refuge around 1906. They are, from left to right, Philomene, Ludger Jr., Ludger Sr., and Joseph. Two additional children were born to Mary and Ludger Gignac while they were at Bethel Creek House of Refuge. Arthur was born in 1906, and Delphine was born in 1907. (Wilson Price.)

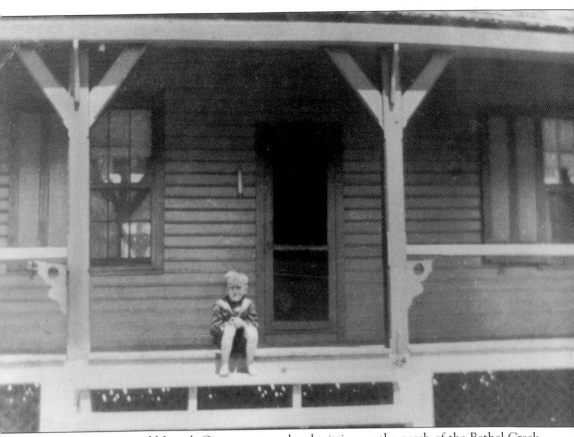

Although six-year-old Joseph Gignac appears lonely sitting on the porch of the Bethel Creek House of Refuge, he had the wilderness to explore and his sister and brothers as playmates. It was worse for the keeper's wife, Mary Gignac, who had moved from Chicago. Her grandson Wilson Price recalled that "she told of collecting rain water to drink, storms, and above all, loneliness." (Wilson Price.)

Englishman Fred Whitehead, the first keeper of Gilbert's Bar House of Refuge, was assistant keeper of the Jupiter Lighthouse before accepting the job. He produced stereoscopic cards with James Armour, keeper of the Jupiter Lighthouse. The back of this stereo card shows Whitehead's name crossed out and replaced with the name of Melville Spencer. The address "St. Lucie," 50 miles north, was the closest post office. (Skip Gladwin.)

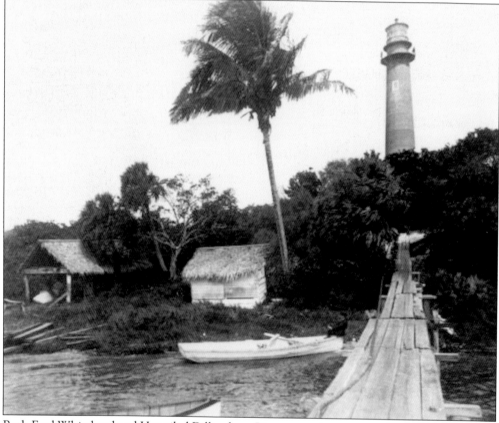

Both Fred Whitehead and Hannibal Dillingham Pierce served as assistant keepers at the Jupiter Lighthouse, shown above, before becoming house of refuge keepers. Lighthouse keepers and their families provided the only help available for victims of shipwrecks prior to the establishment of houses of refuge by the US Life-Saving Service. (Florida Archives.)

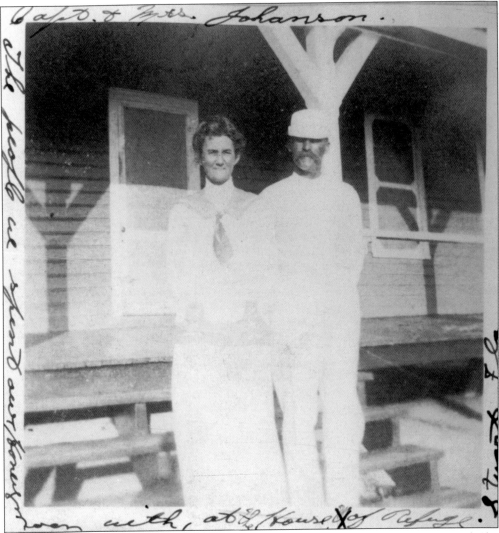

Kate Quarterman Johansen grew up at Chester Shoal House of Refuge on Cape Canaveral. She discovered her future husband, Axel Johansen, who is standing beside her, when he washed ashore after a shipwreck. After being nursed to health, he went back to his native Norway but returned to marry Kate. This 1914 photograph was taken at Gilbert's Bar House of Refuge where Axel was keeper. (Josephine Paradise.)

House of Refuge No 2 Indian River
Saint Lucie. Bavard. co Fla,
June 30th 1879.

Dear Lee,

A person in my present. Sit-
ation is compelled to have patience wheath
he will or no — it has been some four weeks
since your letter of May 21st has been
received — I write now not knowing how
long it will be before an opportunity offers.
to mail this letter, but your friends at

Ohioan Ezra Stoner moved to central Florida where he planted a grove. In 1879, he became keeper of the Gilbert's Bar House of Refuge in order to have an income before his citrus trees produced. Stoner wrote letters north to his son Lee describing his lonely life. Joe Rubinfine, who deals in historical autographs, obtained these letters that are now in the University of Florida's P.K. Yonge Library of Florida History and can be accessed at ufdc.ufl.edu/Aa00031902. (P.K. Yonge Library.)

Hubert Bessey was keeper of Gilbert's Bar House of Refuge from 1890 until 1901. Educated at Oberlin College in Ohio, he settled on the St. Lucie River with his brother Willis, who suffered from tuberculosis. Hubert Bessey is considered to be the first settler of Stuart, Florida. An expert boatbuilder, he continued building regatta-winning sailboats in a structure immediately north of Gilbert's Bar House of Refuge. (David Murray.)

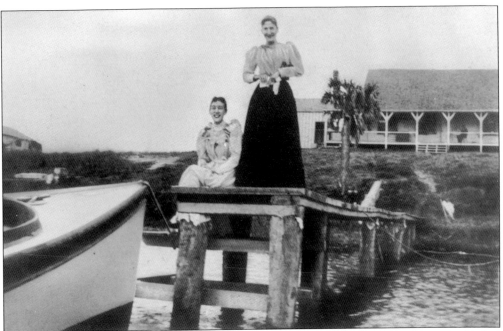

Susan Bessey stands on the dock at Gilbert's Bar House of Refuge with her sister Bessie Shackleford sitting beside her. Their father, W.A. Corbin, sits on the porch. This photograph, taken by Blanche and William Harris of Walton in 1898, is the best known picture of Gilbert's Bar House of Refuge before the upper row of windows was added around 1911. (Historical Society of Martin County.)

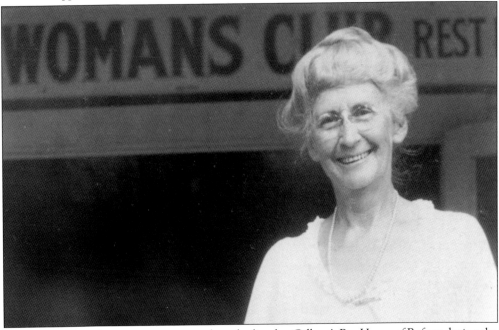

Susan Bessey loved to entertain guests when she lived at Gilbert's Bar House of Refuge during the first five years of her marriage. She recalled those years as her "happiest." After her husband's death in 1919, she continued to live in Stuart and was active in the community. This photograph shows her in 1922 when she was president of the Woman's Club of Stuart. (Emma Taylor Ashley.)

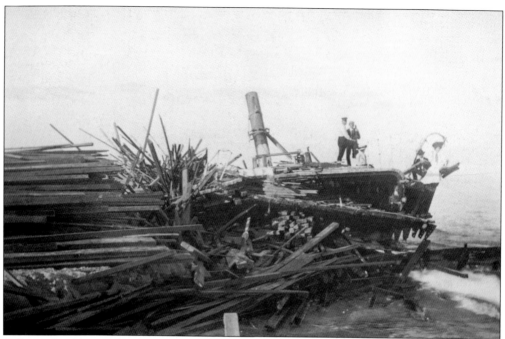

Gilbert's Bar House of Refuge experienced its most active time during the "gale" of October 16, 1904. The ship *Cosme Colzado* wrecked three miles north of the station, and the lumber ship *Georges Valentine* broke apart at the house of refuge. The tiny figure of William Rea, who served as keeper from 1903 until 1907, can be seen on the wreckage wearing a cap and dark trousers. (Florida Archives.)

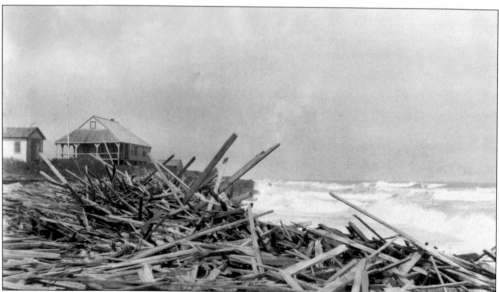

The lumber from the *Georges Valentine* was purchased by Homer Witham and Will Dyer of Stuart; however, it remained on the rocks beside Gilbert's Bar House of Refuge for months. It was eventually used in numerous buildings, but transporting it from the wreck site was no easy task. Since five bodies from the shipwrecked crew were never recovered, people wondered if they might be beneath the lumber. (Agnes Tietig Parlin.)

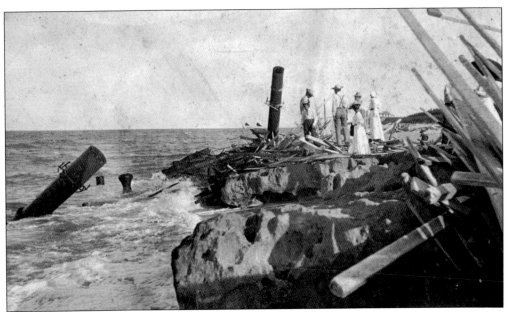

Pioneer families visited the site of the October 16, 1904, shipwreck of the *Georges Valentine* for months after its cargo of lumber was strewn on the rocks beside Gilbert's Bar House of Refuge. The Florida Department of State declared the remains of the wreck an Underwater Archaeological Preserve in 2006 and had it listed in the National Register of Historic Places. (Florida Archives.)

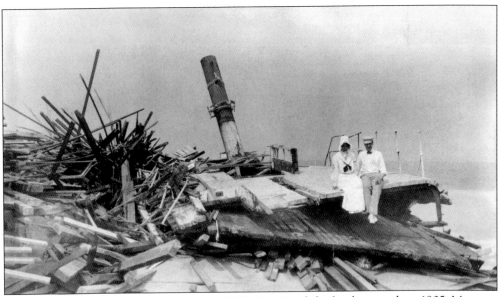

Margaret Andrews and her fiancé, Rudolph Tietig, visited the lumber wreck in 1905. Margaret was the daughter of A.L. Andrews of Cincinnati, Ohio, who built a home on nearby Sewall's Point in 1904. (Agnes Tietig Parlin.)

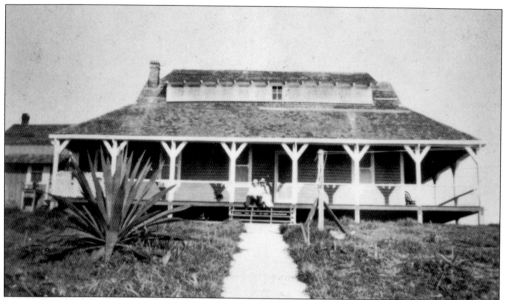

The upper stories of six of the eight remaining houses of refuge were modified around 1911 with rows of windows facing east and west. For some reason, the number of windows was different for each house of refuge. This photograph of Lollie Roebuck and Reginald Kitching honeymooning at Gilbert's Bar in 1914 shows the new lines of the building with 12 windows added to each side. (Carol Mann Ausborn.)

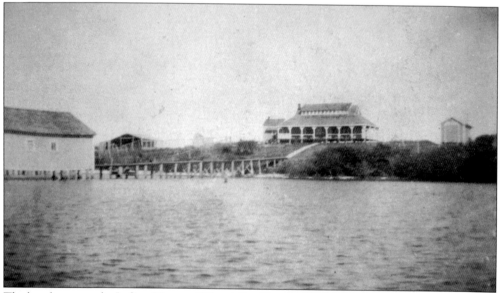

The boathouse on the Indian River at Gilbert's Bar House of Refuge protected sailboats when they were the only mode of transportation. The shed to its right was a workshop for master boatbuilder Hubert Bessey, who was keeper from 1890 until 1900. The boathouse at left housed a small boat provided by the US Life-Saving Service. This photograph was taken after 1911 when the house of refuge was modified with upper-story windows. (Mary Anne Feldhauser.)

Lillie Elder Pierce was born at the Orange Grove House of Refuge on August 15, 1876. Her brother Charles produced a 690-page manuscript about Florida pioneer life. It was edited by Dr. Donald Curl of Florida Atlantic University, published in 1970 as *Pioneer Life in Southeast Florida*, and is required reading for anyone interested in the history of Florida. (Historical Society of Palm Beach County.)

The Orange Grove House of Refuge, No. 3, located on what is Delray Beach today, was an overnight stop for the so-called "barefoot mailmen" who walked the beach carrying mail between Lake Worth and Miami from 1885 to 1893. The term "barefoot mailman" was made popular by the historical novel by Theodore Pratt, published in 1943. (Historical Society of Palm Beach County.)

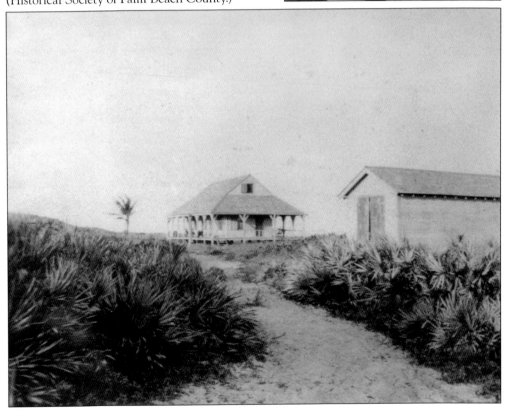

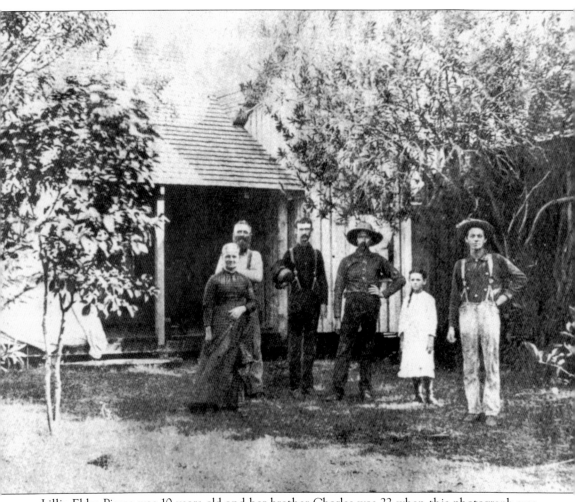

Lillie Elder Pierce was 10 years old and her brother Charles was 22 when this photograph was taken at the Pierce home on Hypoluxo Island in Lake Worth. Her father, Hannibal Dillingham Pierce, was the first keeper of Orange Grove House of Refuge. Her mother, Margaretta, almost died when Lillie was born there on August 15, 1876. Lillie is said to be the first white child born between Jupiter and Miami. The young men in the photograph, including Charles, carried the mail along what was called the "Barefoot Route" from Lake Worth to Miami. Ed Hamilton lost his life carrying the mail when he swam the Hillsboro Inlet on October 11, 1887. Someone had removed the boat used to cross the inlet, and it was surmised that either alligators or sharks killed Hamilton when he tried to swim or wade across. From left to right are Margaretta Pierce, Hannibal Dillingham Pierce, Andrew Garnett, James E. "Ed" Hamilton, Lillie Elder Pierce, and Charles Pierce. (Historical Society of Palm Beach County.)

WE remained on the charming shores of Lake Worth two weeks, hunting, fishing, and visiting the settlers. The boys had now become quite stout, hearty, and rugged, and proposed to walk to Biscayne Bay, instead of sailing, as we found that tramping the beach was a mode •of traveling quite common between the two places, and we were assured that the journey would be quite interesting, and that many rare shells and valuable marine curiosities could be picked up on the beach. The distance is about sixty miles from the lower end of Lake Worth, with three life-saving stations between, where we could sleep and procure the necessary provisions. Only Frank, Ben, and myself

This drawing of the Orange Grove House of Refuge by Lake Worth pioneer Dr. George Potter is an illustration in *Camping and Cruising in Florida* by James A. Henshall, MD, of Cincinnati. Henshall sailed down the east coast of Florida with five of his chronically ill patients in 1878 and published an account of his experiences, first in *Forrest and Stream* then in a book. (Sandra Thurlow.)

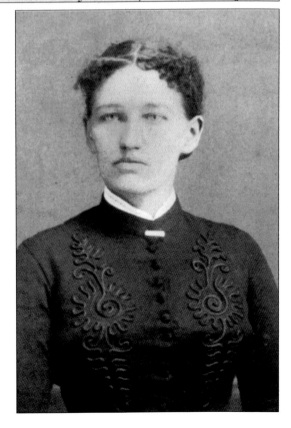

Englishman Steve Andrews was keeper of the Orange Grove House of Refuge for eight years before he married Anne Hubel. Four of their children were born at the house of refuge. Anne ran the Zion Post Office from the station between 1888 and 1892. Since the Orange Grove House of Refuge was one of the stops for the barefoot mailman, the Zion Post Office had pickup and deliveries. (Nancy Moshier.)

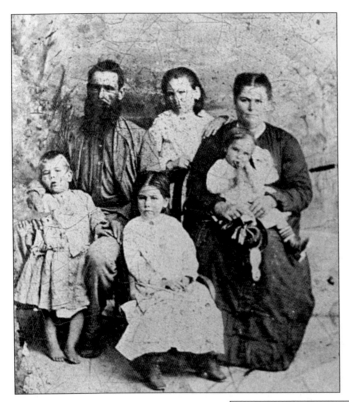

Washington and Mary Shipes Jenkins, who served at the Fort Lauderdale House of Refuge from 1876 to 1883, posed for this family portrait around 1881. Mary, named after her mother, stands between her parents. The other children are, from left to right, Henry, Alberta, and Martha. Mary was the sister of Martha Peacock, whose husband was also a house of refuge keeper. She and Washington later divorced. (Fort Lauderdale Historical Society.)

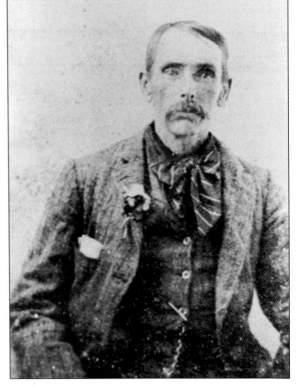

Washington and Mary Jenkins had two children when they moved into the Fort Lauderdale House of Refuge on December 7, 1876. Two more were born while they lived there. When Jenkins was relieved as keeper by Edwin R. Bradley, he was so sick, he had to be carried aboard the *Illinois*, the boat chartered to transport the Bradley and Pierce families to their new house of refuge assignments. (Fort Lauderdale Historical Society.)

This building was the Dade County Court House in Miami after it became the county seat once again in 1899. For a decade, the county seat had been Juno, at the head of Lake Worth. In 1888, the electors of northern Dade County, which stretched all the way to the St. Lucie River, outvoted the Miami residents in the decision to change the location of the county seat. The Miami residents were furious and vowed they would not allow the county seat to be moved and would use force of arms if necessary. When the Miamians went home for dinner, the northern Dade County men decided to physically remove the county record books before the Miamians returned with firearms as they threatened. They loaded the record books in a large canoe and headed north through the Everglades to the Fort Lauderdale House of Refuge. Thinking the Miami men were in pursuit, they put the books upstairs and guarded them with guns, only to discover their pursuers were some of their own men. (Historical Society of Palm Beach County.)

The family of Guy Bradley, the Audubon game warden who was killed by a bird plumage hunter on July 8, 1905, moved into the Fort Lauderdale House of Refuge on July 2, 1883. During Edwin Bradley's time as keeper, several members of his family, including Guy, became sick. Guy's 10-year-old sister Flora died and was buried under a sea grape tree near the house of refuge. (Everglades National Park.)

Perhaps the man standing at the door at the Fort Lauderdale House of Refuge with a sack over his shoulder is a so-called barefoot mailman wearing shoes. The Barefoot Route from Lake Worth to Miami existed from 1885 until 1894. The beach-walking mailmen stayed overnight at the Orange Grove and the Fort Lauderdale Houses of Refuge. (Fort Lauderdale Historical Society.)

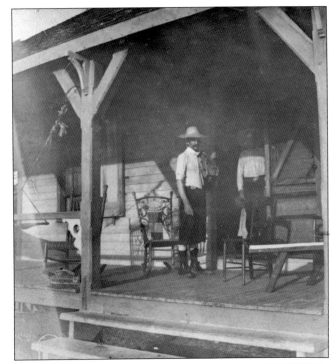

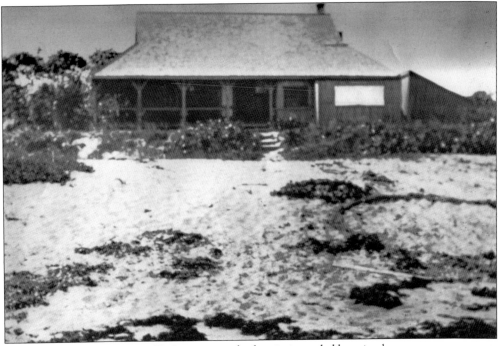

The Fort Lauderdale House of Refuge was not built at its intended location because ocean currents swept the lumber for its construction northward. After almost 15 years, the station, a cistern, the privy, and the boathouse were moved a half-mile south to government-owned land. The original location was where Sunrise Boulevard intersects with North Fort Lauderdale Beach Boulevard today. Its ultimate location was where Bahia Mar is today. (Fort Lauderdale Historical Society.)

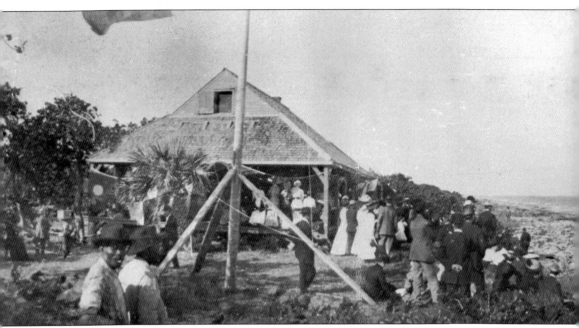

On Christmas Day 1911, practically the whole population of Fort Lauderdale went to the beach for festivities at the house of refuge. This was not the original location of the Fort Lauderdale House of Refuge. In 1876, it was constructed where the lumber floated ashore, not on the government-owned property where it was supposed to be built. Ocean currents interfered with the intended direction of the building materials that had to be delivered by schooner. In 1891, after 15 years of

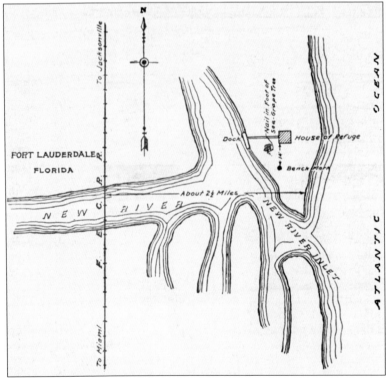

This map, published in the appendix of the *1913 Everglades Report*, shows the location of the Fort Lauderdale House of Refuge in relation to the New River Inlet. The inlet closed when Port Everglades was opened in 1927. The proximity of the Florida East Coast Railway, so clearly shown, diminished the need for houses of refuge that were built when the only access was by water. (Gary Goforth.)

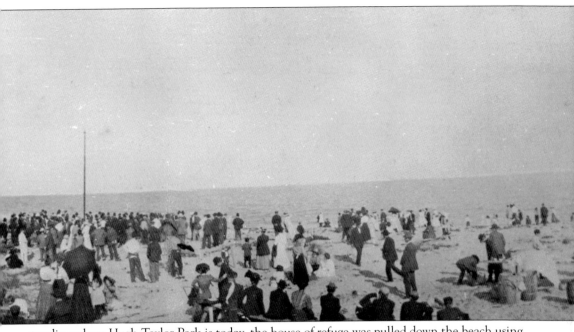

standing where Hugh Taylor Park is today, the house of refuge was pulled down the beach using mules and logs and put in its intended location near the New River Inlet. Not long after this gathering, upper-story windows were added, with eight facing east and eight facing west. (Fort Lauderdale Historical Society.)

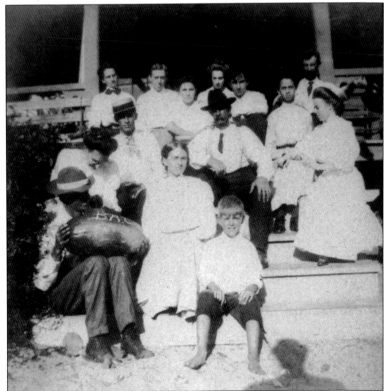

Ivy Cromartie Stranahan, far right, poses with others on the steps of the Fort Lauderdale House of Refuge. In 1899, Ivy became Fort Lauderdale's first schoolteacher. The following year, she married Frank Stranahan, who ran a trading post on the New River. Frank is considered to be the "founder" of Fort Lauderdale, and Ivy was recognized as Fort Lauderdale's and Broward County's "First Lady." (Fort Lauderdale Historical Society.)

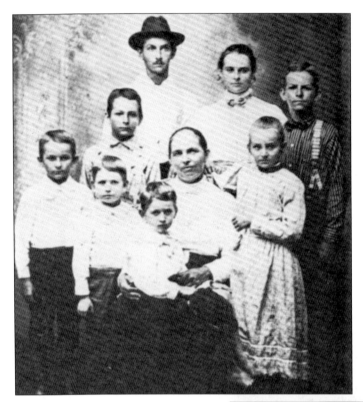

Mary Sullivan Barnott poses with her children around 1900, shortly after her husband, Edward Barnott, was killed in a tornado. He was the first keeper of Biscayne Bay House of Refuge and married Mary in 1877, when she was 13. Mary said she buried several babies in the dunes beside the house of refuge. Edward, wearing a hat, was her first child to survive. (Thelma Peters and the Barnott family.)

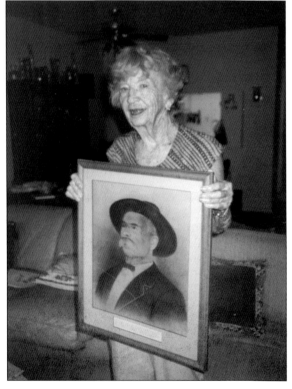

Doris Brady displays a portrait of her grandfather John Thomas "Jolly Jack" Peacock on September 17, 2001. Peacock was keeper of the Biscayne Bay House of Refuge following Ed Barnott and Hannibal Pierce. Previously, he served at Fort Lauderdale and Gilbert's Bar. An Englishman, he arrived in Biscayne Bay in 1870 after being shipwrecked and fathered nine sons and two daughters. According to Ralph Monroe, he was "the most humorous and frolicsome, original and ingenious, eccentric, goodhearted and wayward of men." (Sandra Thurlow.)

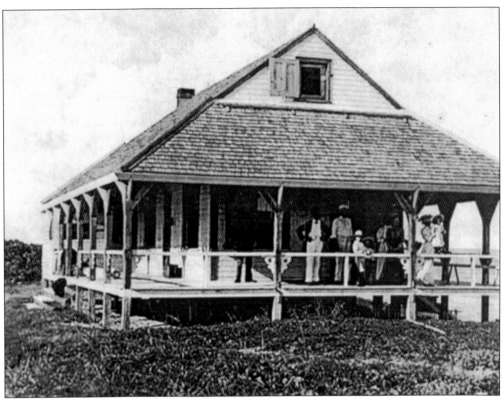

Keeper William H. Fulford and his wife, Mary Ann, pose with guests on the porch of Biscayne Bay House of Refuge in 1898. The porch would later be partially enclosed, and 20 windows would be installed upstairs. The Fulfords are credited with having the first paying guests on Miami Beach, and their 160-acre homestead was the nucleus of North Miami Beach, originally named Fulford. (Sandra Thurlow.)

Martha Shipes Peacock was the sister of Mary Jenkins, who was also the wife of a house of refuge keeper. Two of the Peacocks' brood of nine boys and two girls were born at the Biscayne Bay House of Refuge. When Rafaela was born on February 10, 1885, Keeper Jack Peacock wrote, "Local stranger arrived" in the station logbook. When Richard was born on November 4, 1886, his father entered, "Another local stranger arrived." (Doris Brady.)

Keeper Edward Lapp and his wife, Julia, are representative of all of the keepers of the Smith's Creek House of Refuge, the northernmost of the five that were built in 1886. Edward, who was from New York, and Julia, from Illinois, had four children when they moved to Florida in 1898 and farmed near Daytona. They moved into the Smith's Creek House of Refuge in 1901. The children from oldest to youngest were Walter, Winona, Eleda, George, and Louise. Louise was born at the house of refugee in 1905. The name of Smith's Creek House of Refuge was changed to Bulow House of Refuge after the Bulow Post Office was established on April 21, 1899. Walter, who grew up at the house of refuge, took over as temporary keeper in 1913. (Both, Sheryl Cooper Hicks.)

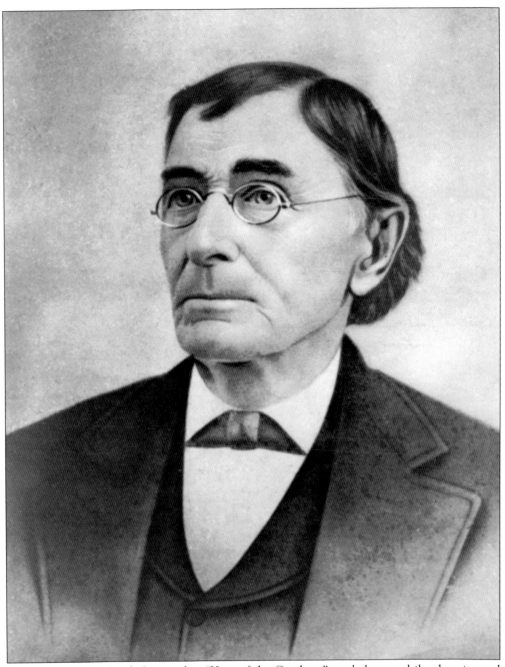

It is a mystery why Jacob Summerlin, "King of the Crackers," cattle baron, philanthropist, and founder of two cities, would take the job of keeper of the Mosquito Lagoon House of Refuge. According to Joe A. Akerman Jr., Summerlin sold most of his operations to his sons in 1883. Official records say he was keeper of Mosquito Lagoon House of Refuge from 1886 until 1890. (Florida Archives.)

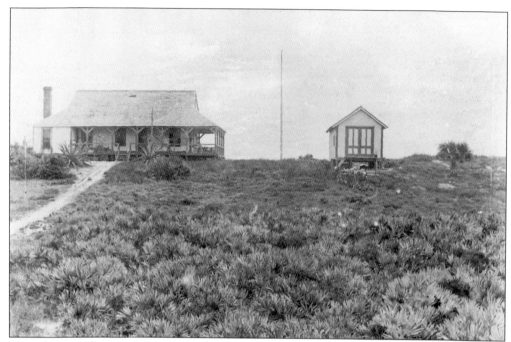

This photograph was taken using a glass-plate negative soon after Samuel Coutant took over the Mosquito Lagoon House of Refuge from Jacob Summerlin in 1891. Palmettos covered the ground on either side of the path that led to the lagoon. All 10 of the houses of refuge were built alike, with a chimney on the north end and a small boathouse to the south. (Historical Society of Martin County.)

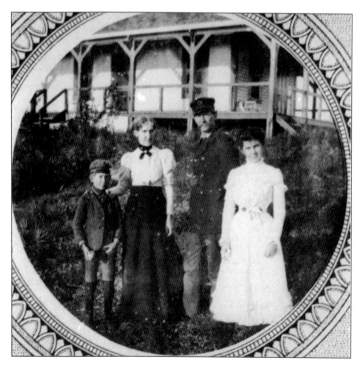

Samuel and Louisa Coutant pose in front of the Mosquito Lagoon House of Refuge with two of their children, Jeanette and Harold. Their third child, Aimee, is taking the photograph. The Coutants served as keepers for 22 years. Samuel, a photographer, had a darkroom at the house of refuge, and taught his son Harold photography. They have a separate chapter because their unique photographic record is representative of all of the keepers' families. (Elwin Coutant.)

Initially, when sailboats were the primary mode of transportation, large boathouses were constructed by the government at each of the houses of refuge. In the early days, getting to the nearest post office required a long sail. Gradually new settlers arrived, and new post offices were opened making for shorter trips. Looking toward the mainland, this view shows the Mosquito Lagoon boathouse. (National Archives.)

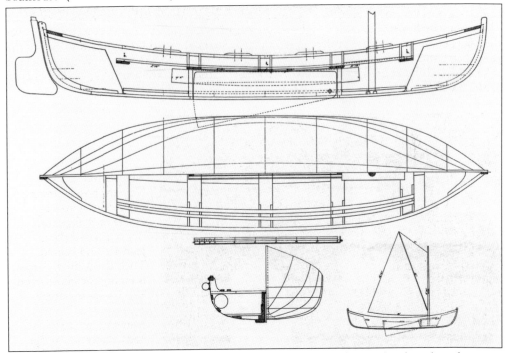

The first five houses of refuge, built in 1876, were equipped with a 22-foot-long boat having a corrugated galvanized iron hull. The boat shown here could be rowed or sailed and was intended for use by the keeper and his family for either supply purposes or for use in a rescue. Use of iron instead of wood for the boat's hull was supposed to reduce boat maintenance, but the boat's heavy weight was often too much for the keeper and family to easily handle. As a result, the later series of houses of refuge, as well as the initial five, were supplied with lighter weight wooden-hulled sailing boats. (Timothy Dring.)

Jerusha Burnham Quarterman spent her entire life on Cape Canaveral, first at the lighthouse, then at Chester Shoal House of Refuge as the wife of Orlando Quarterman. Her sister Anna Burnham married George Quarterman, who was Orlando's brother. Her son Orlando Quarterman Jr. served in the US Life-Saving Service and US Coast Guard. Her daughter Kate married Axel Johansen, who also served in both the US Life-Saving Service and US Coast Guard. (Florida Archives.)

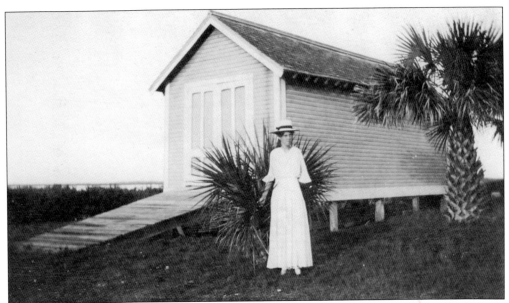

Orlando and Jerusha Burnham Quarterman were the only keepers of the Chester Shoal House of Refuge for its entire existence. Both were members of families connected to the nearby Cape Canaveral Lighthouse and raised their children, Kate, Mary, and Orlando Jr., as they served as keepers. Axel Johansen, a shipwrecked Norwegian who was found on the beach by Mary and Kate, returned to Florida to ask for Kate's hand in marriage. The unidentified young woman standing beside the Chester Shoal boathouse in 1916 represents Kate, who spent her childhood and married life at houses of refuge. (Coast Guard Archives.)

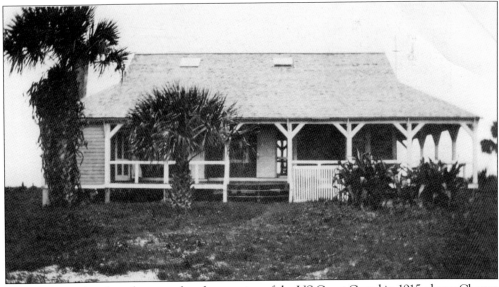

This photograph, taken the year after the creation of the US Coast Guard in 1915, shows Chester Shoal House of Refuge as it looked when Orlando and Jerusha Quarterman retired and turned it over to their nephew George Quarterman Jr. and his wife, Annie. Orlando died in 1928, six months after Jerusha's death. There are two Quarterman family cemeteries within the restricted zone of the Cape Canaveral Air Force Station. (National Archives.)

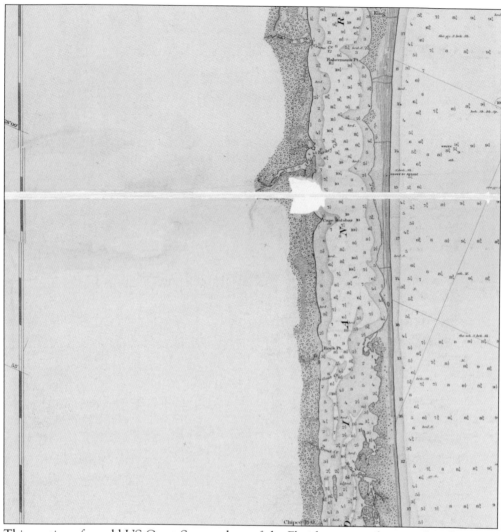

This portion of an old US Coast Survey chart of the Florida coast and approaches shows the location of the house of refuge constructed at Cape Malabar; it had the shortest period of service (only five years) of any of the houses of refuge established by the US Life-Saving Service. (Office of Coast Survey, National Oceanic and Atmospheric Administration.)

205 Main Street Jacksonville Fla

January 3rd, 1905.

Hon S I Kimball
General Supt L S Service
Washington D.C.

Sir: I have the honor to report that the Cape Malabar House of Refuge was destroyed by fire from a bush fire which swept across the peninsula at that point. Exact date not known.

At the time of the fire a number of citizens went to fight & extinguish the flames but they were unable to prevent the buildings catching, & they were entirely consumed.

The fire originated about one mile West of the Station and was accidental in its getting beyond control. This is in addition to the facts previously reported

Very Respectfully
H S Shaw
Superintendent

Cape Malabar House of Refuge, built in 1886, was closed after Joseph Mulvey Hopkins was discharged on December 31, 1891. Joseph and his first wife, Catherine Houston, had four children when he became keeper. After the birth of a son on Christmas Day in 1886, Catherine died. In 1889, Joseph married Henrietta Livingston, who raised Catherine's children and had two more. Catherine Houston Hopkins's hardships when her husband was keeper of Cape Malabar House of Refuge must have been extreme since the 1885 Florida Census indicated she was disabled. Although her burial place is unknown, many family members, including Joseph and Harriet, are buried in Eau Gallie Cemetery within today's Melbourne city limits. No photographs of the Cape Malabar House of Refuge can be found, but this letter and its listing in annual reports of the US Life-Saving Service document its existence. (National Archives.)

The land where the Cape Malabar House of Refuge once stood is now Spessard Holland North Beach Park. Born in Bartow, Florida, in 1892, Spessard Holland was in the Florida State Senate from 1932 to 1940, governor of Florida from 1941 until 1945, and served in the US Senate from 1946 until 1971, the year of his death. A popular site for fishing, the park is located on the beach at 2525 South Route A1A in Brevard County. (Florida Archives.)

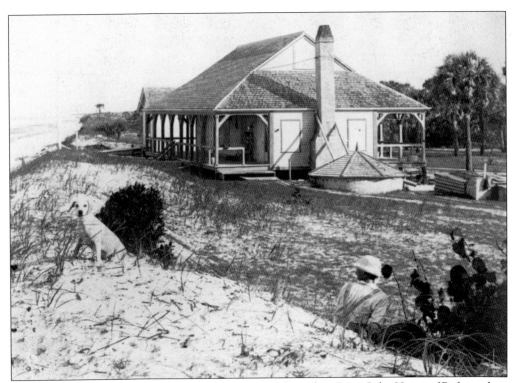

James and Emily Lagow Bell were the first keepers of the Indian River Inlet House of Refuge when it opened in 1886. Emily wrote of their experience in her memoir *My Pioneer Days in Florida*. She told of having to get groceries in a cat-rigged sailboat with a centerboard, putting her four children in it and tying the baby to the centerboard pin. (St. Lucie County History Center.)

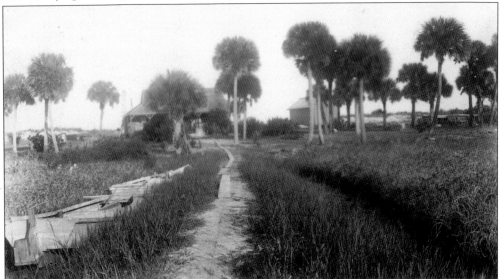

This photograph of the Indian River Inlet House of Refuge was taken looking west from the beach. The boathouse on the Indian River is seen at right. Keepers who followed James Bell were Henry B. Archibald, Harry H. Jenkins, Benjamin W. Jerome, Harry H. Harvey, and Byron Dawley. Very little is known about any of them. (St. Lucie County History Center.)

JUPITER LIGHTHOUSE, FLORIDA.

[Lat. 26° 57′ N.; long. 80° 05′ W.]

DESCRIPTION OF TIDE GAUGE AND BENCH MARK.

A plain wooden tide staff was nailed to a pile of the wharf at Jupiter Lighthouse Jupiter Inlet is very uncertain as to its closing or being open, and the entrance is abou

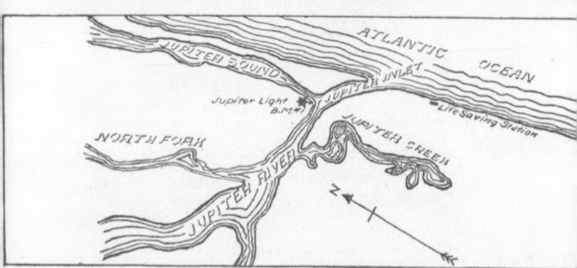

as changeable as it can be, no two tides leaving the bar the same. Tides were observed between April 26 and May 12, 1883, by party of Lieut. H. B. Mansfield, United State Navy, and by party of Assistant B. A. Colonna, between March 20 and 23, 1884.

This chart, published in the Appendix of the US Government's 1913 Everglades Report, provides an excellent visual for the location of the Jupiter Inlet Life-Saving Station, south of the Jupiter Inlet. Today, the Lazy Loggerhead Café, within 120-acre Carlin Park, occupies the site. Carlin Park has tennis courts, picnic shelters, softball fields, volleyball courts, playgrounds, an amphitheater, and 3,000 feet of guarded beach frontage. (Gary Goforth.)

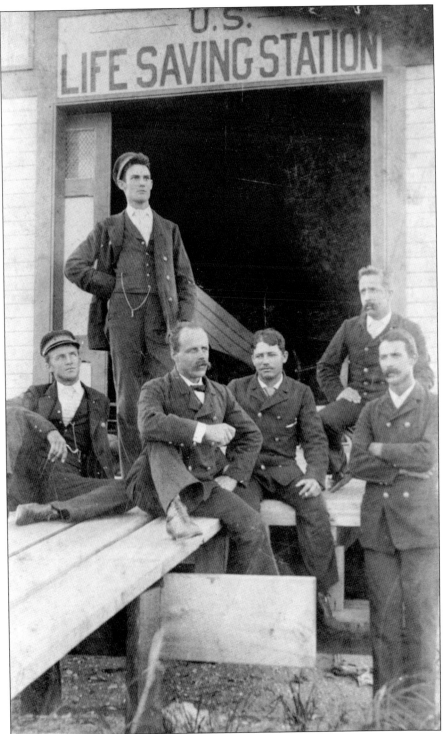

Members of the Jupiter Inlet Life-Saving Station crew pose on the ramp used for surfboat launching. From left to right are Graham King, Charles W. Carlin (standing), John Grant, Daniel Ross, Thomas Mitchell (against building), and Harry DuBois. (Loxahatchee River Historical Society.)

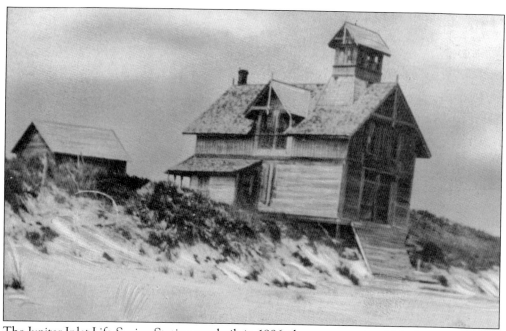

The Jupiter Inlet Life-Saving Station was built in 1886, the same year in which the second series of five houses of refuge were built. It was the only life-saving station on the east coast south of Charleston, where the Morris Island Life-Saving Station was constructed the same year. The architecture of both life-saving stations was referred to as the 1882-type, believed to be designed by J. Lake Parkinson. Even though the Morris Island and Jupiter Inlet Life-Saving Stations were many miles apart, they were organized into the same district under the same district superintendent. Originally, this was District 7; later, it was changed to District 8. Unlike houses of refuge, life-saving stations had a surfman crew trained for sea rescue. Keeper Charles R. Carlin recruited the crew from local residents. This diagram of the Jupiter Inlet Life-Saving Station, drawn as surfman Harry DuBois remembered it, illustrates the general layout and arrangement for a station of this design. (Both, Loxahatchee River Historical Society.)

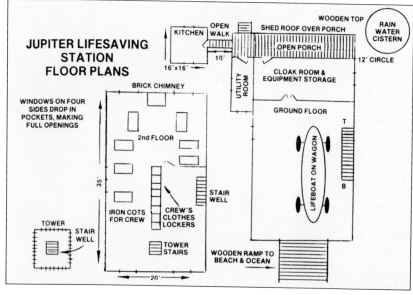

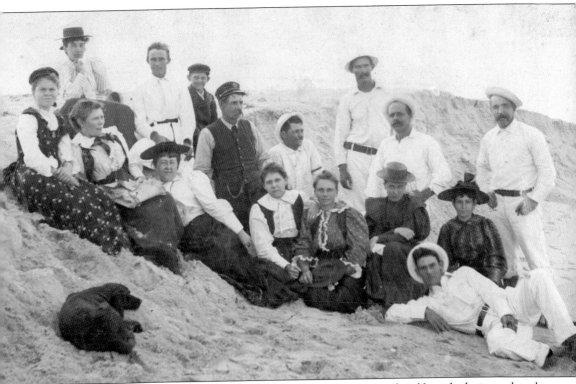

The Jupiter Inlet Life-Saving Station crew posed with wives and girlfriends during a beach celebration. From left to right are (first row) Leah King, Ola Kyle Grant (wife of John Grant), Nora Magill King (wife of Edward B. King), Tag Kyle, Eliza Kyle Cabot (wife of Fred Cabot), Lyda McConnell, Ella Aicher (wife of Conn Aicher), Charles W. Carlin, and the life-saving station dog in the foreground; (second row) Anna McConnell Magill (wife of Fred Magill), Graham W. King Sr., Fred M. Cabot III, Keeper Charles R. Carlin, Daniel Ross, Harry DuBois, Tom Mitchell, and John H. Grant. Keeper Carlin had a son and two sons-in-law on his crew. Conn Aicher was the husband of his daughter Ella May; Graham King was married to his daughter Edith. (Loxahatchee River Historical Society.)

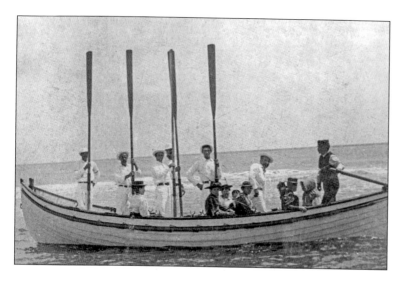

Jupiter Inlet Life-Saving Station crew members allowed their wives to take a ride in their Beebe pulling surfboat after giving demonstrations of maneuvers. The life-saving station crew was on duty for 10 months each year and was off during the calm months of June and July. (Loxahatchee River Historical Society.)

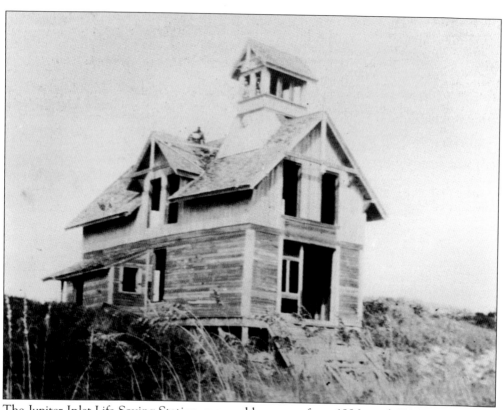

The Jupiter Inlet Life-Saving Station, manned by a crew from 1886 until 1896, continued to be listed in the *US Life-Saving Service Annual Report* through 1901. After 1896, Keeper Carlin resorted to rounding up a crew of available volunteers when one was needed. Finally, Jupiter Inlet Life-Saving Station was closed and its boats and equipment transferred elsewhere. It stood vacant, then was condemned and sold in 1912. Graham King Sr., Keeper Carlin's son-in-law, purchased it and then sold it to Harry DuBois. (Loxahatchee River Historical Society.)

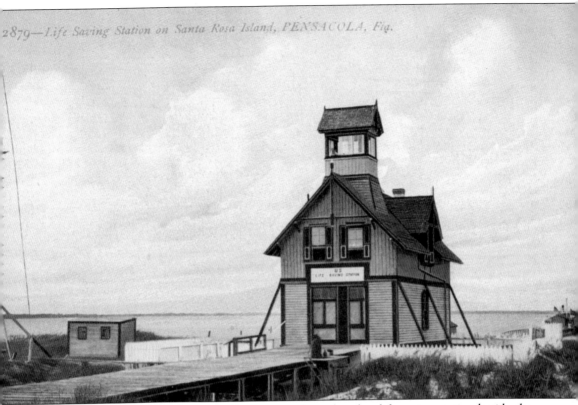

The Santa Rosa Island Life-Saving Station was the only other life-saving station beside the Jupiter Inlet Life-Saving Station built in Florida. It was constructed in 1885 in what was called the 1882-type architectural style design. District 9 had different superintendents than those for Florida's houses of refuge and the Jupiter and Sullivan's Island life-saving stations. In 1906, it was swept away in a hurricane and replaced with a new station of a different architectural style. (University of West Florida Trust.)

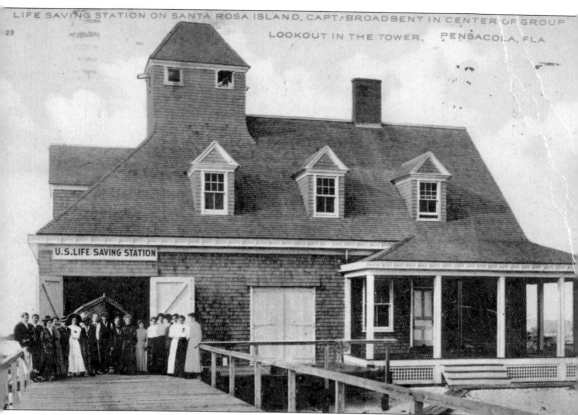

After the first Santa Rosa Island Life-Saving Station was destroyed in a hurricane, this Quonochontaug-type station was built in 1907. Following the creation of the Coast Guard in 1915, it became Santa Rosa Island Coast Guard Station No. 212, remaining in operation until its closure in 1986. Today, the building is part of the Gulf Island National Seashore Campground and Reservation. (University of West Florida Trust.)

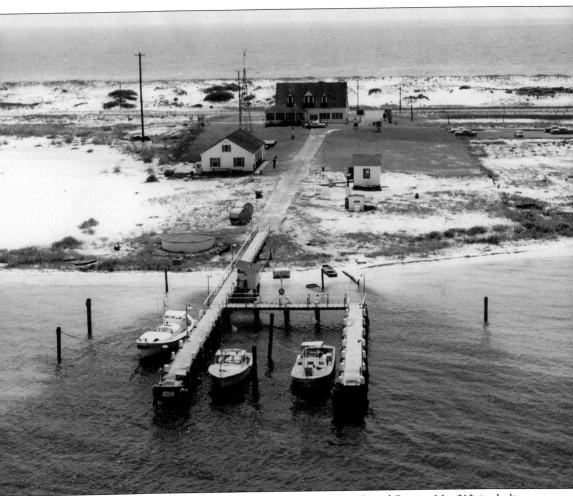

This 1960s vintage photograph shows Santa Rosa Island Coast Guard Station No. 212, including the main station building, outbuildings, and boat mooring facilities. The boats shown are, from left to right, the station's 36-foot motor lifeboat, CG36506; a 30-foot utility boat, CG30574; and a 40-foot utility boat, CG40447. (Coast Guard Historian's Office.)

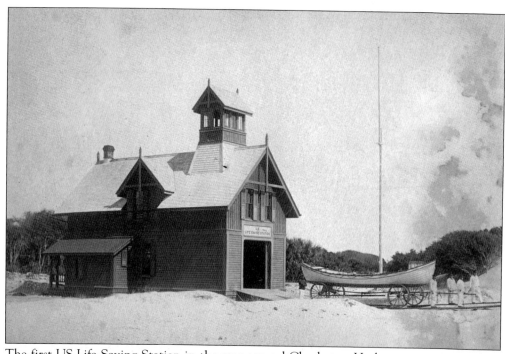

The first US Life-Saving Station in the area around Charleston Harbor was constructed on Morris Island in 1886. This architectural style is referred to as 1882-type. With the diversion of the main ship channel towards Sullivan's Island, the Morris Island station became too remote to render assistance to vessels entering the harbor. Surfmen stand in front of a Beebe-type pulling surfboat on its boat wagon. (National Archives.)

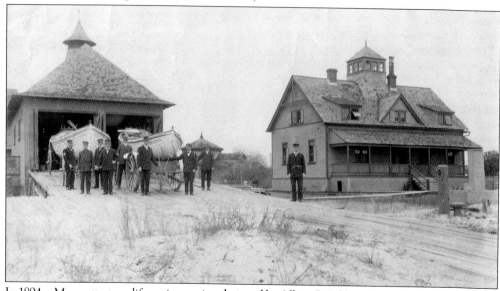

In 1894, a Marquette-type life-saving station designed by Albert B. Bibb was constructed on Sullivan's Island on land donated by the town of Moultrieville, South Carolina. After its completion on August 1, 1895, John Adams became the first keeper. Surfmen stand ready with Beebe-McLellan (left) and Monomoy (right) pulling surfboats on their respective wagons. Men, rather than horses, usually pulled the wagons. (National Archives.)

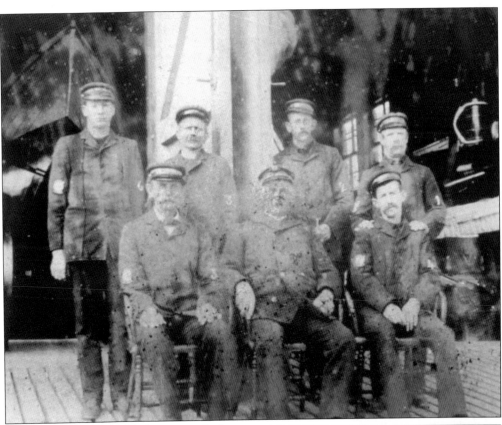

Vincent Coste, at upper left, poses with the Sullivan's Island Life-Saving Station crew. Knowing the year of Coste's birth to be 1879, the date of this photograph is probably around 1901. James J. Coste, Vincent's brother, lost his life in 1898 while on duty trying to save a drowning man. A 2002 newspaper article reported that five generations of Costes had served in the US Life-Saving Service and the Coast Guard. (David Coste.)

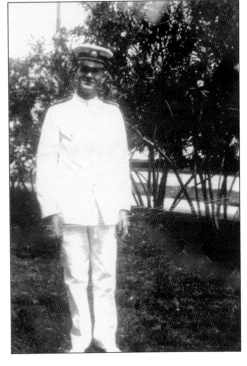

Vincent Coste exemplifies the close connection between Sullivan's Island and Florida's east coast houses of refuge and Coast Guard stations that were within the same district. Vincent Coste started as a member of the crew of the Sullivan's Island Life-Saving Station and later served as keeper of the Biscayne Bay House of Refuge and the Bethel Creek House of Refuge. He became a member of the Coast Guard after its creation in 1915. (David Coste.)

Sullivan Island native Vincent Coste was the first in his family to serve in the US Coast Guard when it was created by merging of the US Life-Saving Service and the US Revenue Cutter Service. His grandfather Napoleon Coste and his father, Napoleon E. Coste, were in the US Revenue Cutter Service. Vincent's son Jimmy was in the US Coast Guard. Jimmy's son Bill, who graduated from the Coast Guard Academy, was the fifth-generation Coste to guard the Atlantic Coast. (Cornelia Coste Austin.)

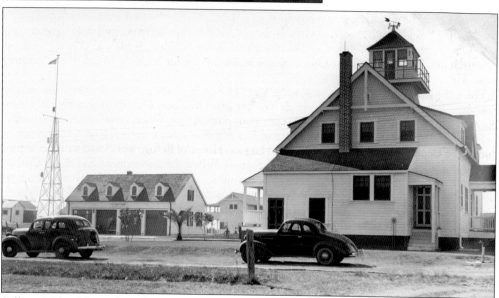

Sullivan's Island Coast Guard Station No. 196, shown in this photograph dated January 20, 1940, was an active installation until 1973 when it was decommissioned. Today, the buildings are designated as the Sullivan's Island Historic Coast Guard District and in the National Register of Historic Places under the purview of the National Park Service. (US Coast Guard Historian's Office.)

Two

THE US COAST GUARD ERA AND BEYOND

Eight houses of refuge were still in operation when the US Coast Guard was created in 1915 from the merger of the US Life-Saving Service with the US Revenue Cutter Service. Positions in the two organizations were retained, but in addition to search and rescue, the stations now had maritime law enforcement as a primary responsibility.

As a military organization, the Coast Guard operated within the US Treasury Department in times of peace and operated within the US Department of the Navy in times of war.

When the United States entered World War I in 1917, things changed significantly at the former houses of refuge. There were now crews of young men with rescue equipment and a supply of rifles and other small arms for patrolling beaches against possible German sabotage.

Following World War I, the Coast Guard's duty of maritime law enforcement became paramount when the Volstead Act (Prohibition) became a part of the US Constitution in 1919. In addition to search and rescue, the Coast Guard now was responsible for bringing so-called rumrunners to justice.

The US Coast Guard had an impossible task. However, to try to stem the flow, the former Fort Lauderdale House of Refuge, which had become US Coast Guard Station No. 207, now became Coast Guard Base 6, growing to enormous proportions. When Prohibition was repealed in December 1933, the US Coast Guard began focusing on cutting costs and facility maintenance due to the Depression. The former Mosquito Lagoon House of Refuge was closed with personnel moved to Ponce de Leon Inlet Coast Guard Station. When the government had threatened to close other stations, local residents protested. Maintaining scaled down facilities turned out to be advantageous when the bombing of Pearl Harbor hurled the United States into World War II. Crews and facilities were again enlarged to provide for beach patrol and the surveillance of the ocean and sky in case of German invasion or sabotage.

With the end of World War II, the US government declared the remaining former houses of refuge surplus. Today, all 10 sites belong to the public.

In 1915, the US Life-Saving Service and US Revenue Cutter Service were merged to form the US Coast Guard. With the addition of the former US Lighthouse Service in 1939 and the US Bureau of Marine Inspection in 1942, the Coast Guard remained part of the US Treasury Department until 1967, when it became part of the Department of Transportation. Finally, in 2003, the Coast Guard was transferred over to the then new Department of Homeland Security. Since the 1915 merger, the roles and missions of the Coast Guard have significantly expanded beyond the original focus on maritime search/rescue and law enforcement to also include military operations, polar- and river-area icebreaking, environmental protection, aids to navigation, recreational boating safety, and maritime safety inspections and enforcement. (US Coast Guard Historian's Office.)

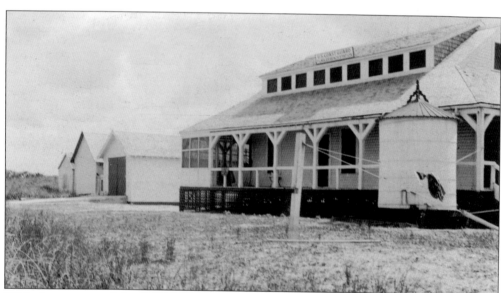

With the creation of the US Coast Guard in 1915, Smith's Creek/Bulow House of Refuge at Flagler Beach became US Coast Guard Station No. 202. The view from the northeast shows the taller of two cisterns for catching rainwater. The garage and boathouse are in the distance. (National Archives.)

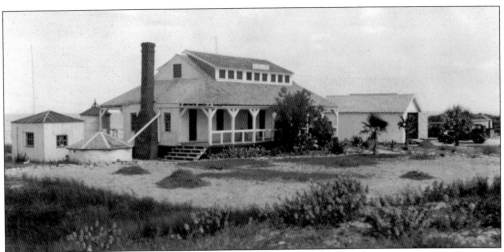

On December 27, 1931, US Coast Guard Station No. 202 had the honor of providing overnight dockage for the presidential yacht *Sequoia*, with Pres. Herbert Hoover and his wife, Lou Henry Hoover, aboard. C.D. Toler, the station's officer in charge, met the yacht and three other vessels, guided them through Matanzas Inlet, and maintained contact until they arrived at the station. This view is from northwest, looking toward the ocean. (National Archives.)

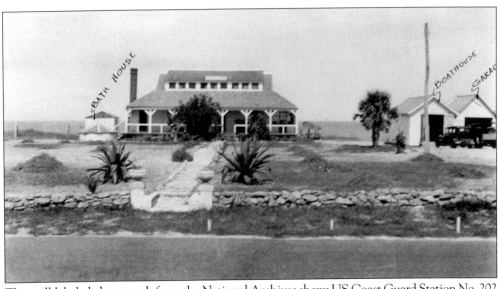

This well-labeled photograph from the National Archives shows US Coast Guard Station No. 202 as it looked on August 8, 1934. Note the century plants that were a feature at houses of refuge, even before the creation of the Coast Guard. An invasive species, their descendants present a problem in today's Gamble Rogers Memorial State Recreation Area at Flagler Beach and the Canaveral National Seashore. (National Archives.)

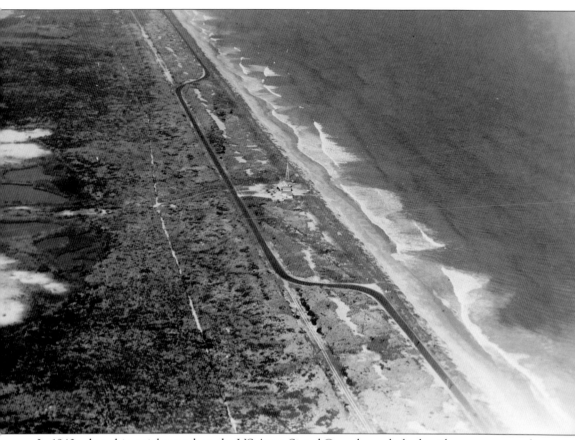

In 1940, when this aerial was taken, the US Army Signal Corps barracks had not been constructed at the site of US Coast Guard Station No. 202. Nathaniel Duke, assigned to the Signal Corps' local radar unit in 1943, said 35 to 40 men lived at the site in wooden barracks built near the shoreline. Today, this land is a camping area in Gamble Rogers Memorial State Park. (National Archives.)

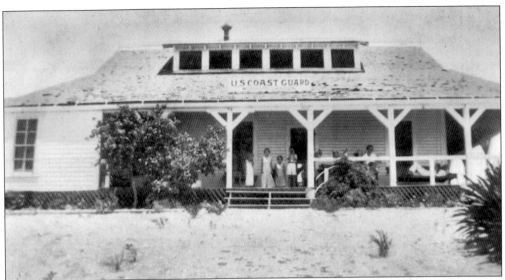

The Midgett family poses with friends at the Mosquito Lagoon Coast Guard Station No. 203. Visiting children, who grew up in Oak Hill three miles by water from the station, were delighted when they had a chance to sleep over. The Midgett children were Ruth, born in 1905; Hilton, born in 1909; Mary, born in 1911; and William Jarvis Midgett Jr., born at the station in 1929. (Bill Dyall and Dana Greatrex.)

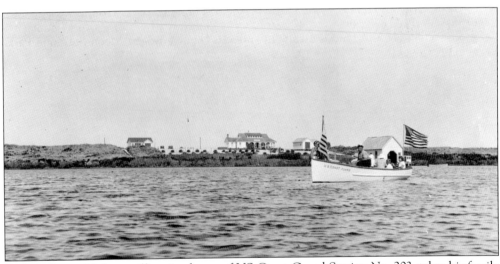

William Jarvis Midgett, officer in charge of US Coast Guard Station No. 203, takes his family for a spin on Mosquito Lagoon in the station's motor launch in 1934. The Midgett children went to school three miles away by boat, in Oak Hill. When they were older, they attended school in New Smyrna, 17 miles away. Jarvis, born in 1929, was only five when this photograph was taken. (National Archives.)

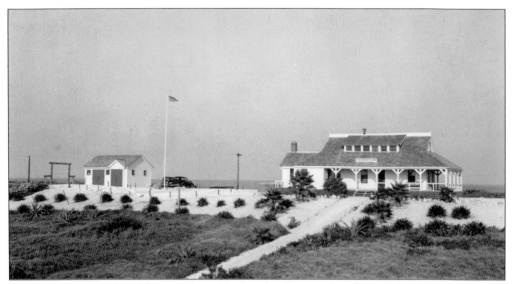

Although US Coast Guard Station No. 203 looked shipshape in this photograph taken in November 1937, it was closed a year and a half later. The station was reactivated during World War II for beach patrol purposes. Standing empty after the war, the building was vandalized and burned in 1946. Today, the site is within the Canaveral National Seashore, and a scale model of the Coast Guard station can be viewed in the Apollo Visitor Center. (National Archives.)

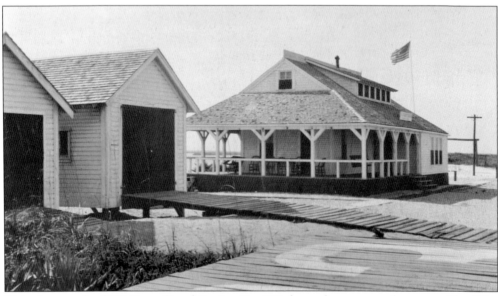

This photograph of US Coast Guard Station No. 203 shows the ramp on the ocean side of the boathouses. The number "203" was painted on the decking to allow passing aircraft to identify which station it was; visible here is part of the "3." Although the former house of refuge was decommissioned in 1939, after the Ponce de Leon Inlet Coast Guard Station opened, it was soon reactivated for beach patrol purposes during World War II. (National Archives.)

Surfman Earl F. Wallace, at the tiller of a self-bailing motor surfboat, was in charge of Mosquito Lagoon Coast Guard Station No. 203 on May 29, 1939, when the national ensign was lowered and the station placed out of commission. All equipment was transferred to the new Ponce de Leon Inlet Coast Guard Station. (Earl. F. Wallace Sr.)

The remains of the boathouse on Mosquito Lagoon and the cistern were all that was left of the site of US Coast Guard Station No. 203 in 1959 when the former Mosquito Lagoon House of Refuge site became John Bartram State Park, named for the famed botanist. It was acquired by the National Aeronautics and Space Administration (NASA) for a buffer zone in 1967. (Florida Archives.)

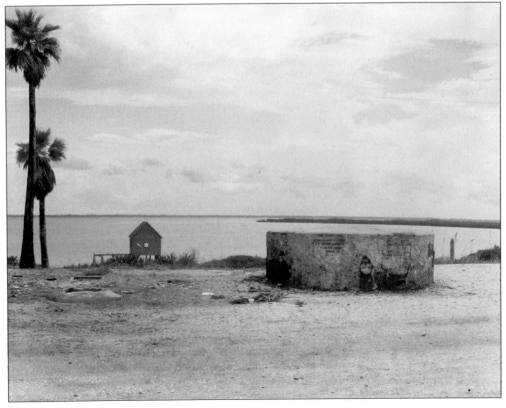

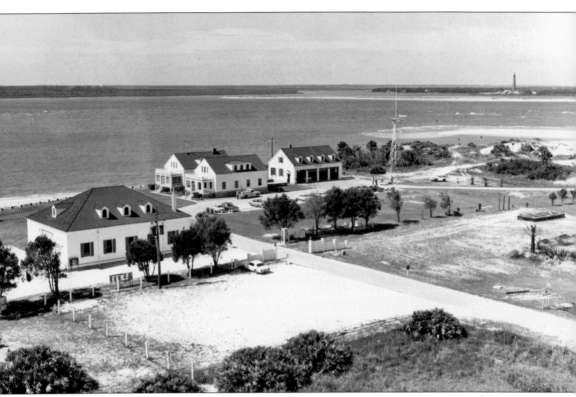

Ponce de Leon Inlet Coast Guard Station replaced Mosquito Lagoon Coast Guard Station in 1939. The old station's number "203" was transferred and appears on the air recognition panel rectangle at right. Florida's US Coast Guard presence was significantly upgraded with the new facility beside busy Ponce de Leon Inlet. Note the Ponce de Leon Lighthouse across the inlet. (National Archives.)

Annie Stewart Quarterman stands in front of US Coast Guard Station No. 204, the former Chester Shoal House of Refuge, where Quartermans served through the years. She exemplifies the intertwining of pioneer families who served at houses of refuge/ Coast Guard stations and the Cape Canaveral Lighthouse. Her Houston relatives were house of refuge keepers, and her husband's grandfather was keeper of the Cape Canaveral Lighthouse. (Mary Anne Feldhauser.)

George Quarterman stands in front of the former Chester Shoal House of Refuge when it was US Coast Guard Station No. 204. He took charge after his uncle Orlando Quarterman's retirement. Orlando was the only keeper of Chester Shoal House of Refuge. Both he and George's father, William George Quarterman, married sisters who were the daughters of Mills Olcott Burnham, keeper of the Cape Canaveral Lighthouse. (Mary Anne Feldhauser.)

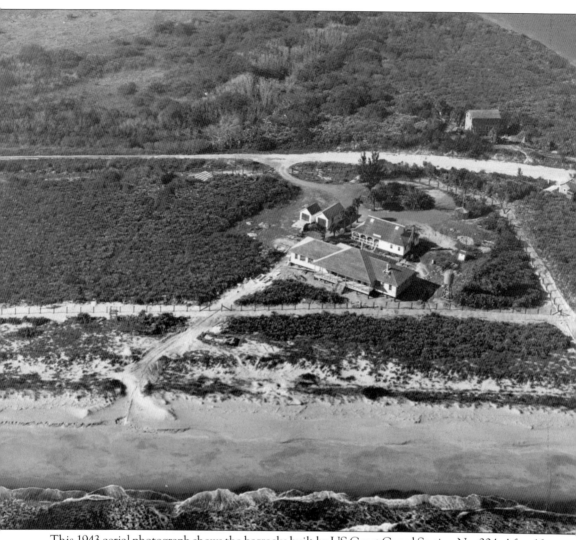

This 1943 aerial photograph shows the barracks built by US Coast Guard Station No. 204. After 16 freighters were torpedoed by German U-boats between Cape Canaveral and Boca Raton in the first half of 1942, coastal patrols were increased. Coast Guard housing, horse stables, and dog kennels were constructed to augment existing facilities. NASA's launch pad 39-A, used by Apollo and shuttle programs, was constructed on the land shown in this photograph. (National Archives.)

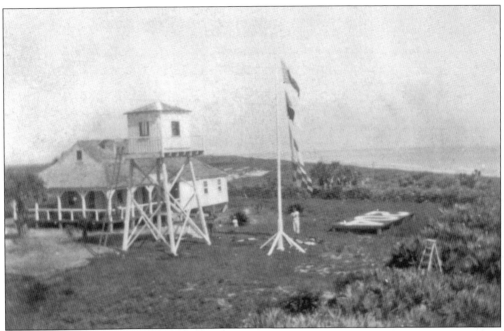

The number "204" facing skyward signifies that this is Chester Shoal Coast Guard Station. The eight houses of refuge still existing in 1915, when the Coast Guard was created, became as follows: Smith's Creek became station No. 202; Mosquito Lagoon, station No. 203; Chester Shoal, station No. 204; Bethel Creek, station No. 205; Indian River Inlet, station No. 206; Gilbert's Bar, station No. 207; Fort Lauderdale, station No. 208; and Biscayne Bay, station No. 209. (Mary Anne Feldhauser.)

The hatches are open in this photograph of Chester Shoal Coast Guard Station No. 204. Roof hatches, rather than windows, were installed on two former houses of refuge: Chester Shoal and Indian River Inlet Coast Guard Station No. 206. (Mary Anne Feldhauser.)

A sign with "US Coast Guard Chester Shoal Station" is over the door on the west side of the building that was constructed as a house of refuge in 1886. Modifications were made to the houses through the years. The kitchen now extended onto what had previously been an open porch. Boards are propped against the chimney, which had probably recently been rebuilt. (National Archives.)

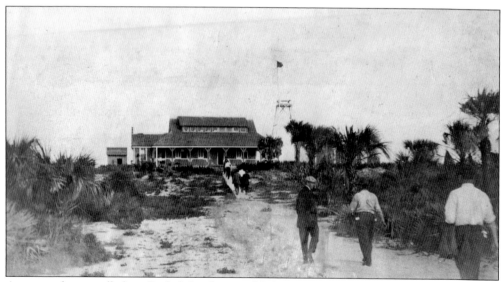

A group of men walk from Bethel Creek toward US Coast Guard Station No. 205, which was destroyed by fire on January 11, 1917. This is the only known photograph showing the house after it was modified with the upper bank of windows, nine on front and back; the same number as on Smith's Creek House of Refuge. (Vero Beach Press Journal Archives Indian River County Main Library.)

Lookout towers were a feature of both houses of refuge and Coast Guard stations. This tower stood on the beach in what is now Jaycee Park in Vero Beach. The US flag with 48 stars, flown from 1912 until 1959, had probably only been in use a decade when this photograph was taken. (National Archives.)

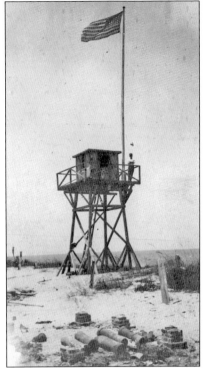

James W. Harrington served at Gilbert's Bar Coast Guard Station No. 207 and at Fort Pierce Coast Guard Station No. 206 in 1942 before being assigned to horse patrol along Vero Beach. During World War II, Coast Guardsmen patrolled in pairs on horseback between 5:00 p.m. and 6:00 a.m., leaving the station every half hour. Their mission was to report any enemy forces or saboteurs along the coast. (James W. Harrington.)

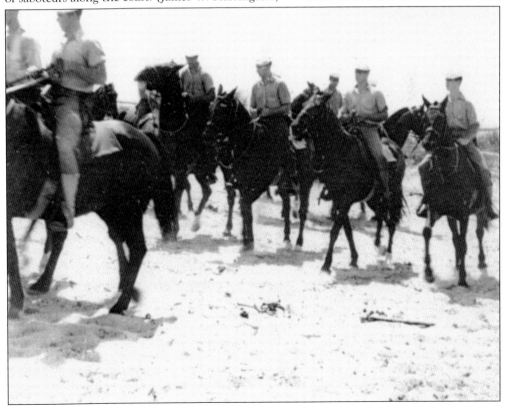

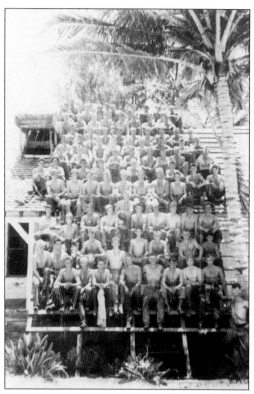

During World War II, Fort Pierce became a huge US Navy amphibious training base. Commissioned January 26, 1943, US Amphibious Training Base Fort Pierce brought thousands of men to train on Hutchinson Island on both sides of Fort Pierce Inlet. Fort Pierce Inlet Coast Guard Station No. 206, south of the inlet, and the former Indian River Inlet House of Refuge on the north side were inundated with trainees. The former house of refuge was ultimately incorporated into an obstacle course used to train members of Naval Combat Demolition Units (NCDU). In this photograph, NCDU trainees pose on the ramp constructed over the historic building. (Robert A. Taylor.)

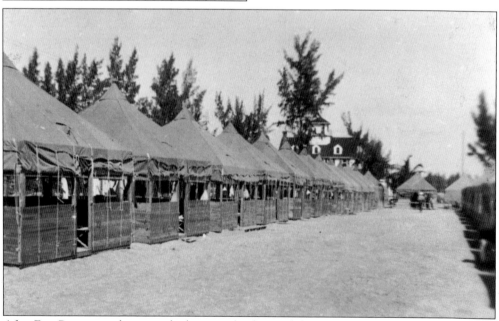

After Fort Pierce was chosen as the location for the amphibious training base, a tent city sprung up around the Coast Guard station, visible in the distance. According to Coast Guardsman James Harrington, "The Navy personnel did not have the quality of facilities that we enjoyed. Whereas their sailors had to stand to eat at boards placed on poles to serve as tables, we ate indoors, family style." (National Navy UDT-SEAL Museum.)

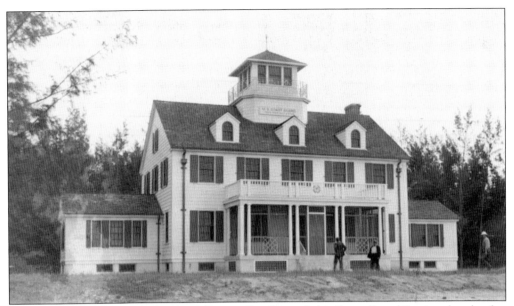

Three men inspect the north side of the new Fort Pierce Inlet Coast Guard Station shortly after it was constructed in 1937. Six years later, the facility seemed palatial in comparison, when the amphibious training base was established and tens of thousands of servicemen lived in tents and in makeshift housing in the surrounding area. (National Archives.)

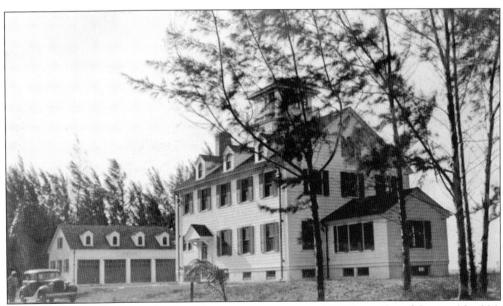

A woman stands on the south side of the recently constructed US Coast Guard Station No. 206. The Colonial Revival–style station and boathouse are referred to as "Roosevelt type" because they were constructed during Franklin Roosevelt's administration. The two-and-a-half-story buildings have lookout tower cupolas that became less functional over time. The former Coast Guard station now serves as the headquarters for the Ocean Research and Conservation Association. (National Archives.)

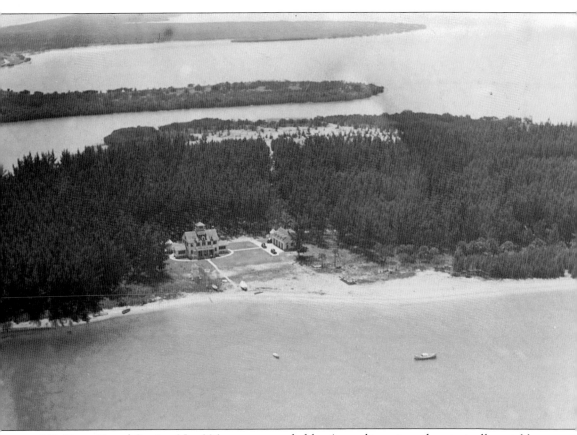

US Coast Guard Station No. 206 was surrounded by Australian pines that typically quickly overtake disturbed land in south Florida. When the Fort Pierce Inlet was opened 1921, dredged sand from the channel was pumped on surrounding land. More sand was deposited when the cut was deepened and a turning basin dredged in 1929. Thumb Point on Fort Pierce's South Beach can be seen in the upper part of the photograph. (National Archives.)

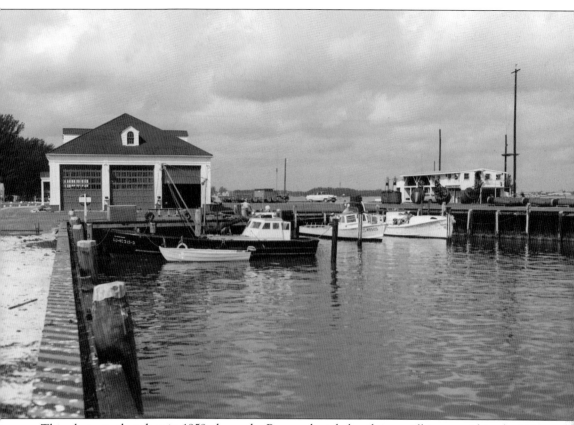

This photograph, taken in 1959, shows the Roosevelt-style boathouse still in use within the US Coast Guard's modern facility at 900 Seaway Drive, near the Fort Pierce Inlet. The boats shown are, from left to right, a 40-foot buoy boat, CG40319-D, with a small outboard motorized skiff alongside; a 40-foot utility boat, CG40505; and 36-foot motor lifeboat, CG36449. (National Archives.)

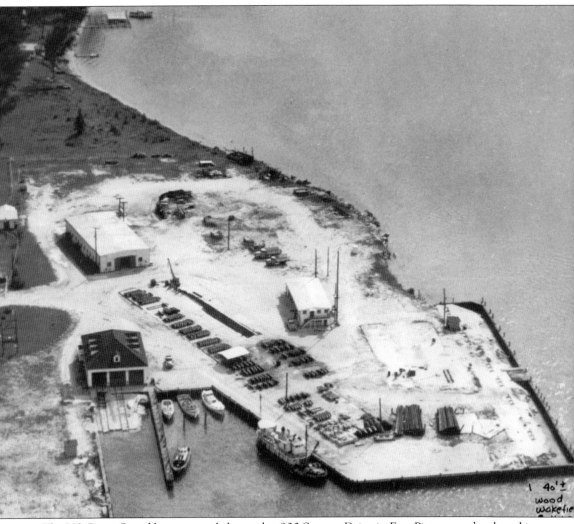

The US Coast Guard base presently located at 900 Seaway Drive in Fort Pierce was developed in the early 1950s to replace the buoy depot, previously located on Taylor Creek, north of Fort Pierce. In this 1955 photograph, the lighthouse/buoy tender *Althea* and a smaller 40-foot-long buoy boat are in the basin. Both were used to tend buoys, light post/towers, and waterway markers in the area. New dredge and fill work and a recently installed bulkhead are visible. (National Archives.)

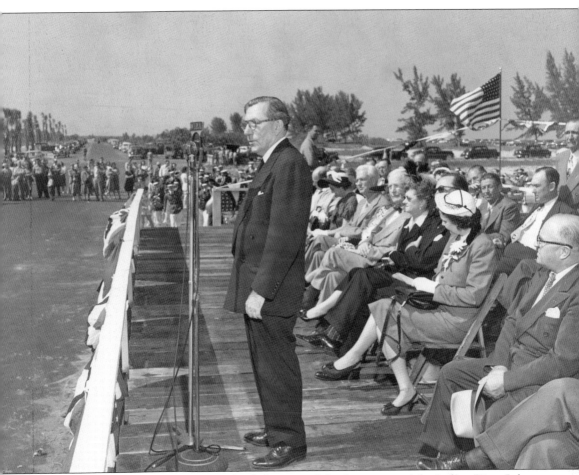

US senator Claude Pepper speaks at the dedication of the former site of the Indian River Inlet House of Refuge/US Coast Guard Station No. 206 as a roadside park named in his honor on August 8, 1950. Today, it is the site of the National Navy UDT-SEAL Museum, 3300 North Highway A1A, North Hutchinson Island, Fort Pierce, Florida. (Florida Archives.)

Officer in charge Axel Johansen, at left, stands with his crew at US Coast Guard Station No. 207 around 1917. From left to right are Axel Johansen, W.I. Baker, Lawson Zeigler, Earl J. Ricou, Shelby McCulley, L.J. Walker, Harold Wybrecht, Fred Hall, and Veril Silva. Axel and Kate Johansen were serving as keepers at Gilbert's Bar House of Refuge when the US Coast Guard was created. (Verdimay McCulley Stiller.)

Lawson Ziegler, whose mother and stepfather owned Bentel's Bakery in Stuart, poses on the dock at US Coast Guard Station No. 207. The shed where Hubert Bessey built his regatta-winning sailboats when he was keeper of Gilbert's Bar House of Refuge can be seen in the background. (Garnett Early.)

Charles Culpepper stands at the helm of a Type S motor surfboat. When Culpepper and his family lived at Gilbert's Bar Coast Guard Station No. 207 in the mid-1930s, a motorboat was used to patrol for rumrunners, as well as to take his two children to school in Jensen. This photograph was probably taken when Culpepper was reassigned to Gilbert's Bar Coast Guard Station No. 207 during World War II. (Earl F. Wallace.)

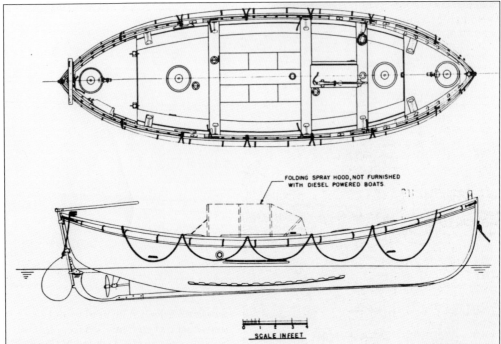

FOLDING SPRAY HOOD, NOT FURNISHED
WITH DIESEL POWERED BOATS

SCALE IN FEET

By the 1930s, many of the remaining former houses of refuge still in operation had their older and less capable motorboats replaced by a 25-foot, 10-inch-long Type S or SR motor surfboat, which had a self-bailing capability. This type of boat provided the keeper and crew with a much more seaworthy craft capable of being used for rescue operations under heavy weather, as well as for routine supply and patrol duties. (Timothy Dring.)

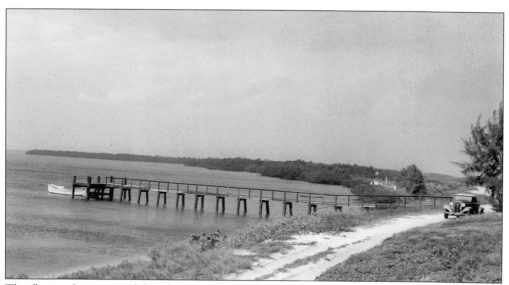

The flag in the center of the photograph flies above the boat shack of Capt. Louis Bartling, a victim of a shipwreck who lived near the Gilbert's Bar House of Refuge for decades. Born in Germany in 1865, he died when his stove exploded on November 19, 1958. An unofficial caretaker and mascot who taught knot tying to Coast Guard recruits, he was part of the property's history. (National Archives.)

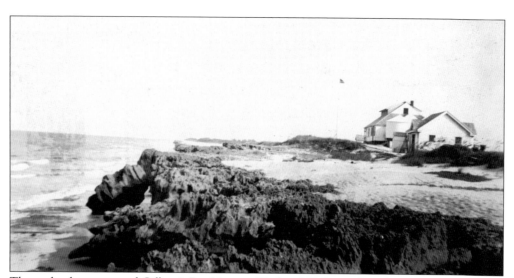

The rocks that protected Gilbert's Bar House of Refuge/US Coast Guard Station No. 207 from erosion also created cascades of saltwater that poured over the house of refuge when the surf was high. One can see that moving the structure away from the surf was necessary. The new cisterns can be seen in this photograph taken on January 11, 1937. (Mae Coventry Axtell.)

Two Coast Guardsmen stand on the porch of Gilbert's Bar House of Refuge/US Coast Guard Station No. 207 on Hutchinson Island near Stuart on July 11, 1937. The cisterns constructed in 1935 dominate the south end of the former Gilbert's Bar House of Refuge. (Mae Coventry Axtell.)

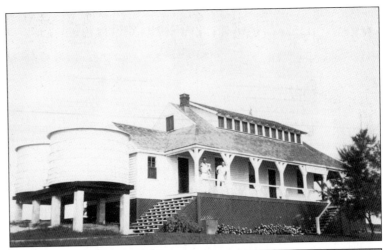

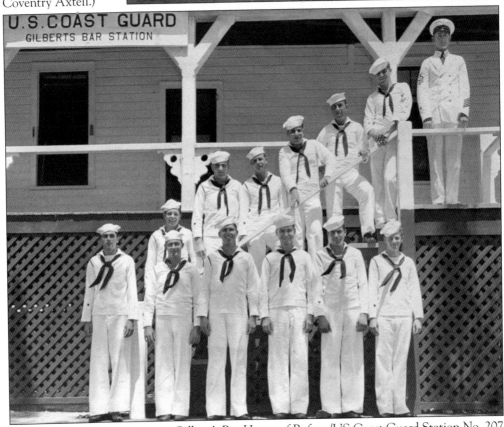

This photograph of the crew at Gilbert's Bar House of Refuge/US Coast Guard Station No. 207 appeared in a booklet published by the *Stuart News* on October 7, 1943, celebrating the completion of the Federal Recreation Building in Stuart. From left to right are (first row) S1c. Charles J. Telesco, S2c. J.W. Gilliam, S2c. William L. Shuppert, S1c. Carl Cohen, S1c. George L. Hamill, and S1c. Steve P. Vanno; (second row, up stairway) S1c. Norman N. Jeffry, S1c. Thomas Rex Ingram, S1c. Hugh E. Jordan, S1c. Nicholas A. Pintado, Coxswain Joe Lewein, Commissaryman A.L. Brown, and Chief Boatswain's Mate Tommie Lewis (the officer in charge). (Florida Photographic Concern photograph, courtesy Joyce Gideon Schultz.)

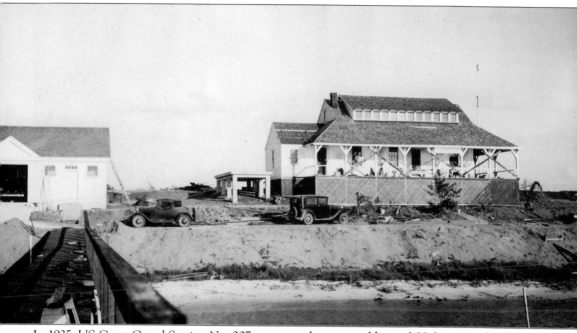

In 1935, US Coast Guard Station No. 207 was moved west an additional 30 feet away from the surf to protect the facility against shoreline erosion and storm damage. Charles Culpepper, the officer in charge, and his family continued their routines as the station was slowly moved with block and tackle. A boathouse/garage was built at this time, as well as two huge wooden cisterns. Only the platforms for the cisterns are seen in this photograph. (National Archives.)

US Coast Guard Station No. 207 stood empty after it was decommissioned in April 1945 until the Bureau of Land Management offered the buildings and 16.56 acres to the Martin County Board of County Commissioners for $165.60 in 1955. The Historical Society of Martin County, created to turn the buildings into a museum, had a chain-link fence erected to protect the property soon after it was purchased. (Bob Cross.)

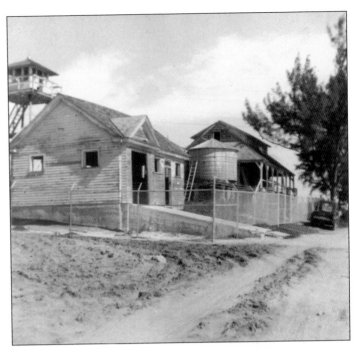

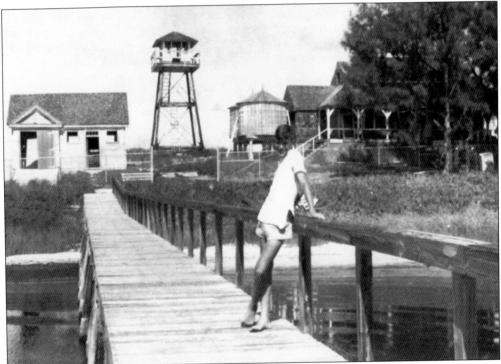

Fourteen-year-old Bob Cross tagged along with his dad, William Cross, of Orlando, who was hired to construct a chain-link fence around Gilbert's Bar House of Refuge. On May 10, 1955, the property was officially leased to the newly formed Historical Society of Martin County. However, the Martin County commissioners agreed to expend $7,000 for repairs and improvements so the historic property could be used as a museum. The fence was their first expenditure. (Bob Cross.)

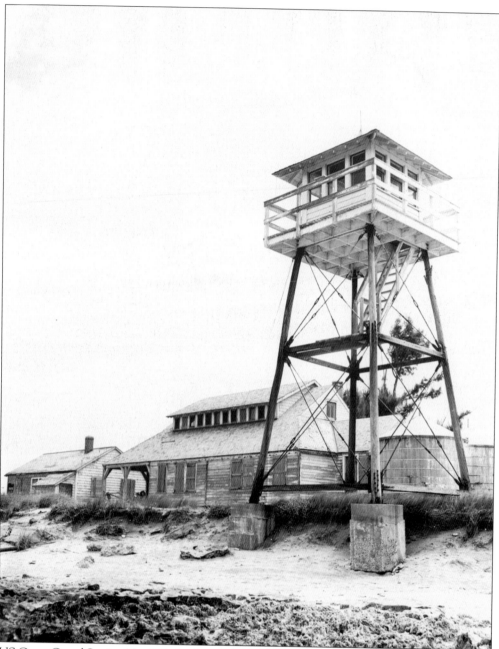

US Coast Guard Station No. 207, the former Gilbert's Bar House of Refuge, stood abandoned for a decade after it was decommissioned in 1945. In 1949, the worst hurricane in the area's history demolished concrete motel units just south of it, but the old buildings and tower remained standing. Erosion caused by the hurricane is evident in this photograph taken on July 27, 1950. (Sandra Thurlow.)

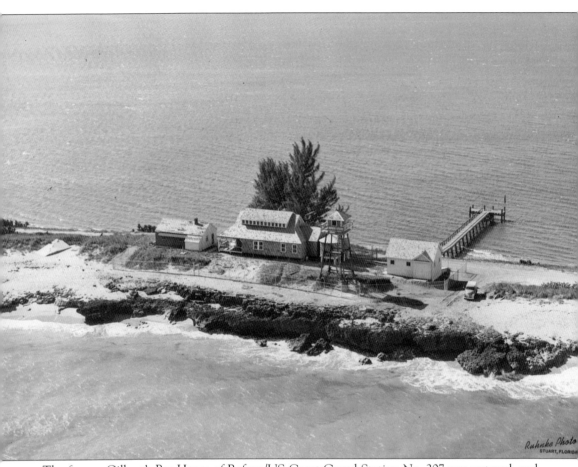

Ruhnke Photo
STUART, FLORIDA

The former Gilbert's Bar House of Refuge/US Coast Guard Station No. 207 was restored, and historical artifacts and memorabilia were put on display. More than 2,000 people attended the opening of the House of Refuge Museum on January 15, 1956. It was an art studio, a local history museum, and became the headquarters for Ross Witham's Head Start program for sea turtles. When the original Elliott Museum was constructed nearby in 1961, the local history exhibits were moved there, and the former Gilbert's Bar House of Refuge became a maritime museum. Today, the Gilbert's Bar House of Refuge Museum focuses on its own history with the US Life-Saving Service and Coast Guard, local shipwrecks, and even its years being a house of refuge for sea turtles. The only surviving house of refuge continues to be operated by the Historical Society of Martin County, and the rock outcropping that has protected the building since 1876 continues to do so. (Sandra Thurlow.)

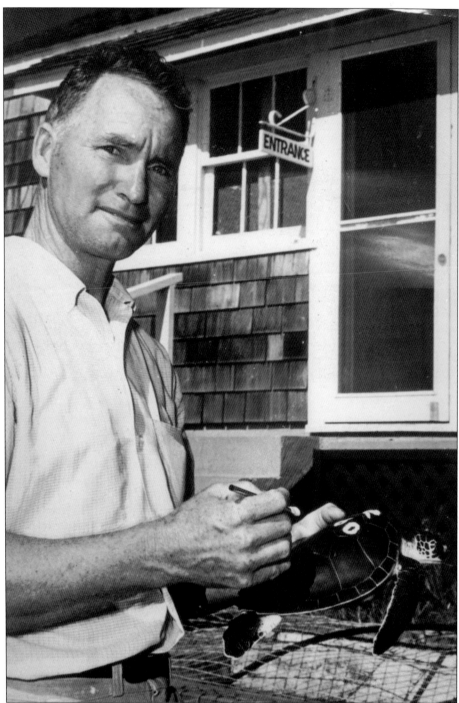

Ross Witham was walking on the beach as therapy for an injury sustained in World War II when he found a baby turtle entangled in seaweed. The incident launched his career in marine biology. For decades, the former Gilbert's Bar House of Refuge was a refuge for sea turtles, where their eggs were incubated and the baby turtles were raised in tanks for 6 to 12 months before being released. (Sandra Thurlow.)

On January 15, 1956, over 2,000 people traveled to Hutchinson Island for the grand opening of the Gilbert's Bar House of Refuge Museum. Cars had to travel across the wooden Jensen Beach Bridge because the Stuart Causeway and "Bridges to the Sea," later named the Evans Crary Sr. Bridge and the Ernest F. Lyons Bridge, were not opened until 1958. (Sandra Thurlow.)

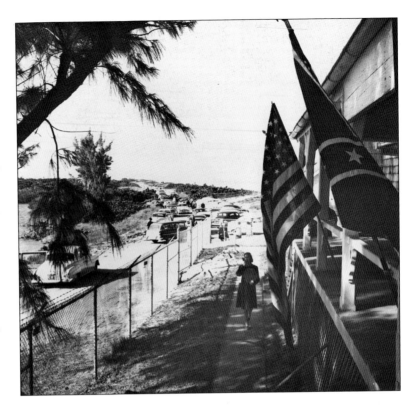

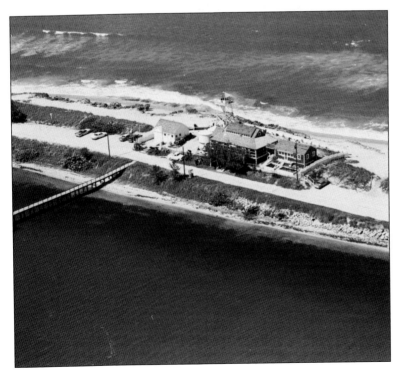

This aerial photograph by Arthur Ruhnke shows the new Gilbert's Bar House of Refuge Museum with concrete tanks for giving sea turtles a "head start." These were constructed on the Indian River side of a structure originally built as a mess hall for US Coast Guard Station No. 207 in 1942. (Sandra Thurlow.)

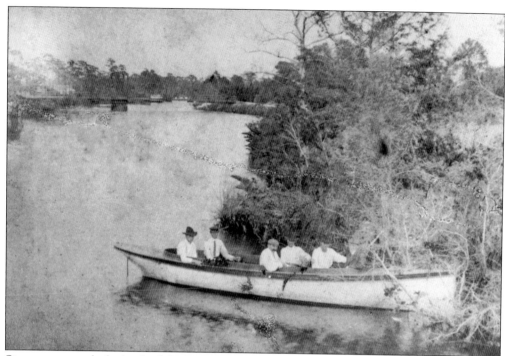

Six men approach the bank of the New River in motor launch No. 1316, built around 1915 and used by US Coast Guard Station No. 208 until its closure in 1920. The first bridge connecting the city of Fort Lauderdale to the beach, where the House of Refuge was built in 1876, was open to the public in January 1917, two years after the former house of refuge became a Coast Guard station. (Florida Archives.)

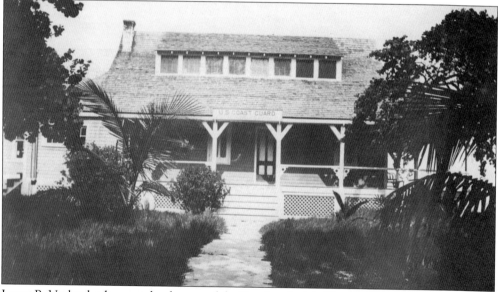

James B. Veeland, who served as keeper of the Fort Lauderdale House of Refuge from 1908 until 1914, was followed by Charles Skogsberg, who was keeper in 1915 when the US Coast Guard was created. This photograph, showing the west side of US Coast Guard Station No. 208, was taken during Skosberg's early years. (US Coast Guard Historian's Office.)

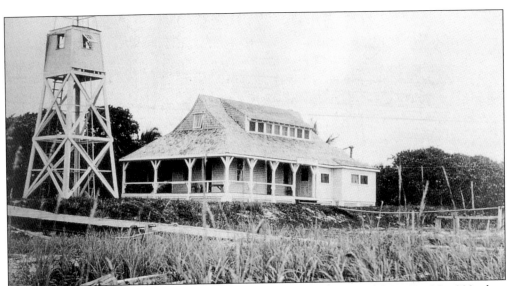

Beach erosion was undermining the lookout tower at US Coast Guard Station No. 208 when this photograph was taken. The tower, used for surveillance during World War I, was augmented by coastal patrols on foot, on horseback, and on motorcycles. The enclosed section of the wraparound porch shows how the former houses of refuge were continually being modified. (National Archives.)

Charles Skogsberg, wife Josephine, and daughter Charlene stand by the steps of US Coast Guard Station No. 208 around 1915. A beach casino was built nearby, and in 1917, a bridge made the beach accessible to automobiles. Remoteness was a thing of the past. Charles Skogsberg remained in charge through World War I; he retired in April 1925. (Fort Lauderdale Historical Society.)

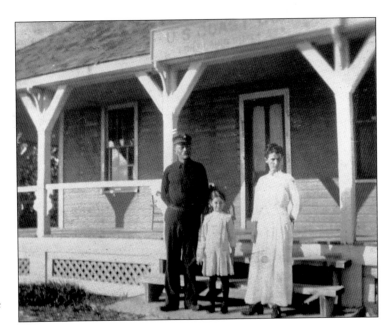

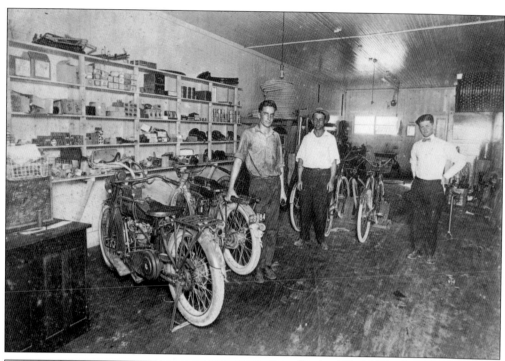

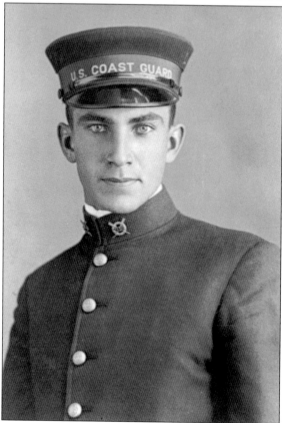

During World War I, twelve Indian motorcycles were acquired by the US Coast Guard to use for patrolling Florida's beaches. Although surfmen who were experienced repairing motors were selected to be riders, the motorcycles were often inoperable. Saltwater, deep sand, logs, and rocks played havoc. Surfman Wallace King, of US Coast Guard Station No. 208, stands beside a motorcycle in W.C. Leaird's bicycle shop in Fort Lauderdale. (Fort Lauderdale Historical Society.)

Portraits of early US Coast Guardsmen are rare. This one of Wallace King, who served on motorcycle patrol for US Coast Guard Station No. 208 in Fort Lauderdale, is a treasure. In 1920, King lived with his mother and two sisters in his brother-in-law Bloxham Cromartie's home. Cromartie was the brother of Ivy Cromartie Stranahan, founder of Friends of the Seminoles and wife of Frank Stranahan, the founder of Fort Lauderdale. (William R. Wells II.)

Originally located in Miami, US Coast Guard Prohibition Base Six moved to Fort Lauderdale and assumed the property of the former house of refuge, which, with the help of Mother Nature's shoreline sand accretion, had expanded to 33 acres. The facilities grew to include 65 buildings, including officers' housing, enlisted barracks, a seaplane hangar, horse stables, dog kennels, an armory, and a radio room with a tower. (National Archives.)

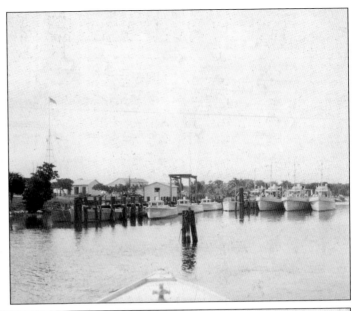

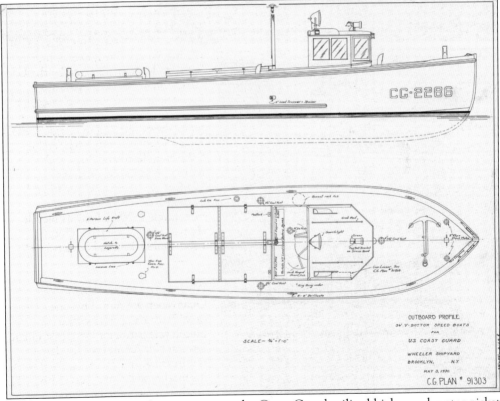

During the Prohibition enforcement years, the Coast Guard utilized high-speed motor picket boats, such as the 34-foot-long Wheeler model illustrated here, to patrol for and intercept any incoming motorboats being used for illegal smuggling of alcoholic beverages. Base Six was provided with a number of these picket boats for this purpose, along with larger 75-foot-long patrol boats. (National Archives.)

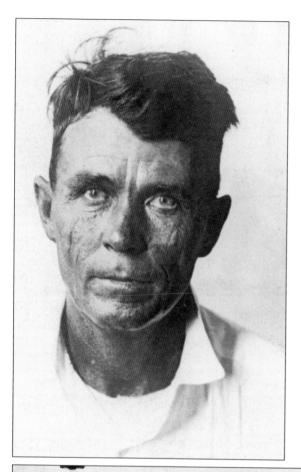

Base Six has the dubious distinction of being the site of the only public execution in Broward County's history. During a routine patrol in 1927, James Horace Alderman's boat was stopped for inspection. Alderman shot and killed three members of the government's boarding party—Robert K. Webster, Sidney C. Sanderlin, and Victor A. Lamby. (US Coast Guard Historian's Office.)

Receiged this Death Warrant August 14, 1929 and executed it by proceeding from Jacksonville, Florida to Miami, Florida, on August 14, 1929, and removing the within-named James Horace Alderman from Dade County Jail, at Miami, Florida, to the Broward County Jail at Ft. Lauderdale, Florida on August 15, 1929. Further executed this Death Warrant by transferring the within-named James Horace Alderman from the Broward County Jail in Ft. Lauderdale, Florida to Coast Guard Base No. 6, near Ft. Lauderdale, Florida, and there hanging the within-named James Horace Alderman by the neck until pronounced dead by the attending physician, W. T. Lanier of Miami, Florida, during the forenoon of August 17, 1929, in pursuance to instructions contained in this Warrant.

B. E. DYSON, U. S. Marshal

By: *Leo M. Mack*
Leo M. Mack, Chief Deputy
and *Mathews*
O. H. Mathews, Deputy

After two years in jail, Alderman and Robert E. Weech, who had also been on the rumrunning boat's crew, were brought to trial. When Alderman was sentenced to be hung, tourist-conscious Broward County officials demurred. The judge ruled that Alderman was a pirate and should be hung at the port where he arrived after his arrest. The execution took place at dawn on Base Six. (National Archives.)

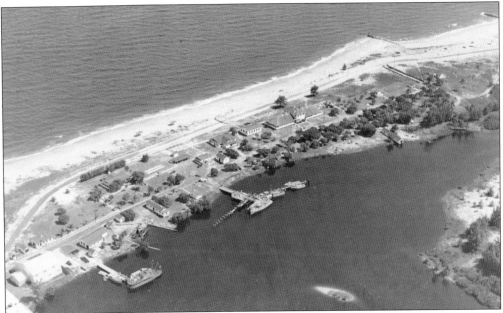

This aerial view of Base Six, located where the Fort Lauderdale House of Refuge stood, shows the former New River Inlet (note the jetties). After the opening of Lake Mabel Cut that eventually became Port Everglades, the old inlet closed by shoreline sand accretion. February 22, 1928, marked the official opening of Port Everglades. (National Archives.)

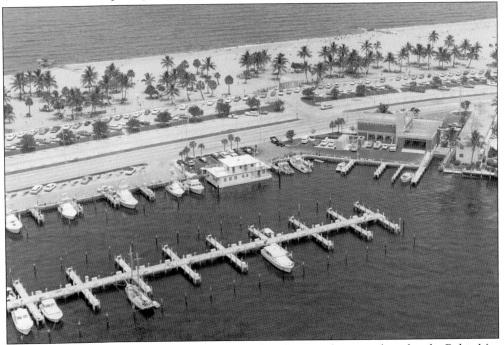

The US Coast Guard houseboat in the center of this photograph was anchored at the Bahia Mar Yachting Center, near where the Fort Lauderdale House of Refuge once stood. The once desolate beach became a spring break mecca for American college students and was made even more popular after the release of the movie *Where the Boys Are* in the winter of 1960. (National Archives.)

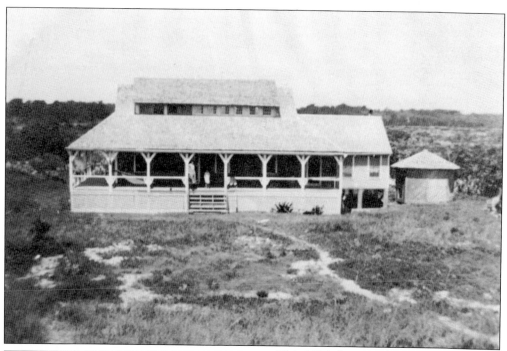

This 1915 photograph of the east side of the Biscayne Bay House of Refuge shows its condition when it became US Coast Guard Station No. 209 after the creation of the US Coast Guard. Miami Beach was still a wilderness, but within five years, this would change greatly. (National Archives.)

Orlando A. Quarterman Jr., posing with his second wife, Henrietta, grew up at Chester Shoal House of Refuge where his father was the only keeper. Orlando Jr. was keeper of the Biscayne Bay House of Refuge from 1907 until 1914. At the time, he was married to Beulah Estelle Ward and had two daughters, Edith and Grace, born in 1904 and 1907. Orlando married Henrietta Lunderman in 1918. (Sonny Witt.)

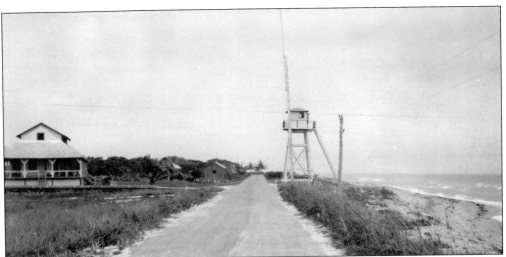

On April 27, 1920, when this photograph was taken of US Coast Guard Station No. 209, its former wilderness location was starting to change. Miami Beach, incorporated in 1915, was booming. The wooden Collins Bridge, built in 1913, would be replaced by the Venetian Causeway in 1925. The County Causeway had been completed in February 1920 using dredged sand from Government Cut channel improvements. (National Archives.)

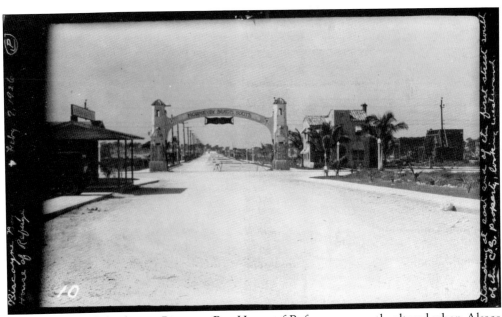

The area around the former Biscayne Bay House of Refuge was greatly altered when Alsace native Henri Levy arrived in 1922 and began two years of around-the-clock dredging to create Normandy Isle from a swampy area in Biscayne Bay. He was also instrumental in the construction of the causeway connecting the mainland to the beach near US Coast Guard Station No. 209. "Normandy Beach South" appears on this arch immediately south of the Coast Guard property in this photograph dated February 7, 1926. (National Archives.)

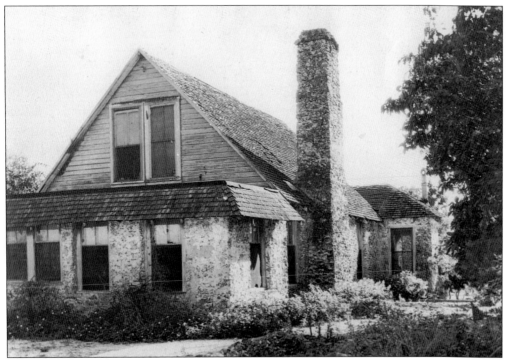

The boom-time development apparent near US Coast Guard Station No. 209 was happening throughout Florida. Former refuge keeper William H. Fulford constructed this house on his 160-acre homestead and became postmaster of Fulford in 1901. Mary Ann and William Fulford lived in this home built of local limestone rock until 1913 when they sold their property to developers. The Town of Fulford was incorporated in 1926. (City of North Miami Beach.)

This Fulford-by-the-Sea monument was constructed at the entrance to the development that bore the name of Biscayne Bay House of Refuge keeper William H. Fulford. A year after the incorporation of the Town of Fulford, the City of Fulford was incorporated by the Florida Legislature. In 1931, Fulford was reincorporated as the City of North Miami Beach. The monument still stands at the intersection of Northeast 172nd Street and Northeast Twenty-Third Avenue in North Miami Beach. Its inclusion in the National Register of Historic Places is pending. (City of North Miami Beach.)

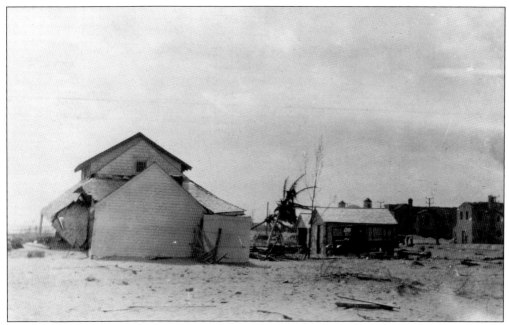

Both US Coast Guard Station No. 209, the former Biscayne Bay House of Refuge, and US Coast Guard Station No. 208, the former Fort Lauderdale House of Refuge, were so damaged by the devastating hurricane of September 19, 1926, that they had to be demolished. This photograph of US Coast Guard Station No. 209 was taken on December 9, 1926. (National Archives.)

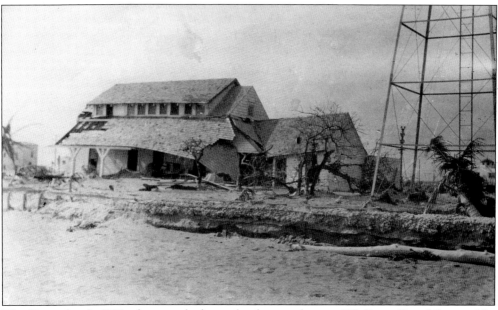

This December 9, 1926, photograph shows the damage done to US Coast Guard Station No. 209, the former Biscayne Bay House of Refuge, during the 1926 hurricane. The historic building, constructed 50 years earlier when what became Miami Beach in 1915 was a wilderness, was beyond repair. The property became a city park in exchange for a site on Causeway Island where US Coast Guard Station Miami Beach remains today. (National Archives.)

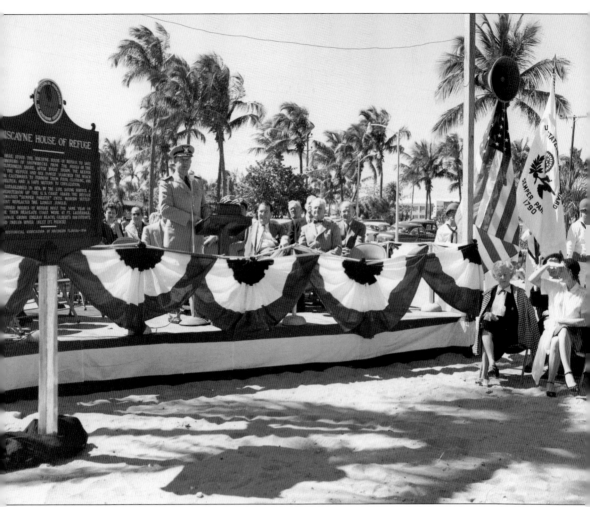

Capt. S.P. Swicegood, commander of US Coast Guard District 7, speaks at the March 7, 1954, dedication of the original Biscayne House historical marker, placed at Seventy-Second Street and Collins Avenue on Miami Beach where the house of refuge once stood. In 2005, the City of Miami Beach replaced the original marker that was sponsored by the Historical Association of Southern Florida with a large bronze marker. It is located in busy North Shore Park on land that was owned by the federal government beginning in 1875. Following the hurricane of 1926, the property became an overgrown wasteland, and in 1941, after a 14-year effort, details were worked out with the government to exchange the land for a site created on Causeway Island beside MacArthur Causeway. Today, Causeway Island is the location of Base Miami Beach of US Coast Guard District 7. (Florida Archives.)

Three

THE COUTANT FAMILY AND THE MOSQUITO LAGOON HOUSE OF REFUGE

Of all the families who served at houses of refuge, only the family of Samuel Coutant, who was keeper of the Mosquito Lagoon House of Refuge for 22 years, left a photographic record. Consequently, the Coutants' images of daily activities, the interior and exterior of the house, boats, outbuildings, excursions, and visitors are valuable representations of all the families who served in the US Life-Saving Service in Florida.

The Coutant family had isolated duty, but those who served 14 years earlier with the first five houses of refuge were even more isolated. Although all 10 houses of refuge were the same size and style, furnishings varied according to each keeper's situation in life. Other families, especially bachelors, had simpler furnishings. The Coutants owned nice furniture and even had a phonograph. Their period of service was a long one, so they had time to accumulate things and, so to speak, "feather their nest." Cisterns may have provided water to the kitchen sink, but there was no indoor plumbing.

Mosquito Lagoon was in the second series of five houses of refuge built, and the Coutants did not receive their assignment until 1890. Elvin Samuel Coutant was keeper of the Mosquito Lagoon House of Refuge from 1890 until 1912. He was born in Greenwich, Ohio, in 1852 and married Louisa Hobson in Mount Gilead, Ohio, in 1876. Louisa was two years his junior. After managing a jewelry store in Des Moines, Iowa, the family, which included two daughters at the time, moved to Florida, near Ormond. Samuel became captain of the schooner *Corrinne*, owned by Hiram B. Shaw. When Shaw became superintendent of District 7 of the US Life-Saving Service in 1890, he appointed Samuel as keeper of the Mosquito Lagoon House of Refuge.

A son, Elwin Harold Coutant, was born in Ormond on May 28, 1890, right before the family of five moved into the house of refuge. The Coutants' daughters, Aimee Ethel and Jeanette Rachael, were 13 and 5 years old, respectively, when the family made the move.

Jeanette's daughter Sarah Howes Prado and Harold's son Elwin Coutant supplied the photographs for this chapter.

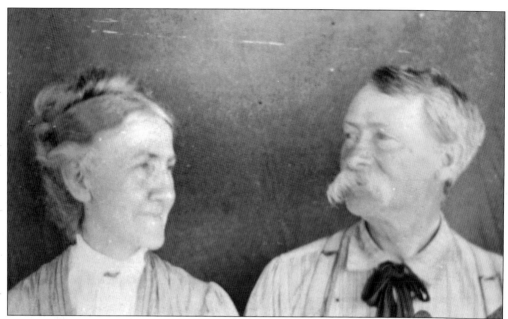

Samuel and Louisa Coutant were keepers of the Mosquito Lagoon House of Refuge for 22 years, from 1890 until 1912. Both were born in Ohio, and they married in Mount Gilead, Ohio, Louisa's hometown, in 1876. After their marriage, Samuel managed a wholesale jewelry store in Des Moines, Iowa. They ended up in Florida due to health problems. (Elwin Coutant.)

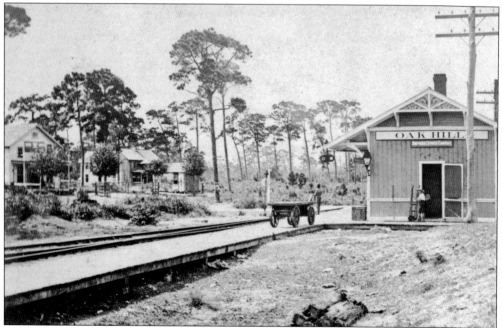

Oak Hill was located on the mainland slightly north of the Mosquito Lagoon House of Refuge. It was about a three-and-a-half mile trip by sailboat. The Oak Hill Post Office, established September 28, 1875, was the place where all of the keepers of the Mosquito Lagoon House of Refuge went to send and receive mail. By 1893, what would become the Florida East Coast Railway reached Oak Hill. (Sarah Howe Prado.)

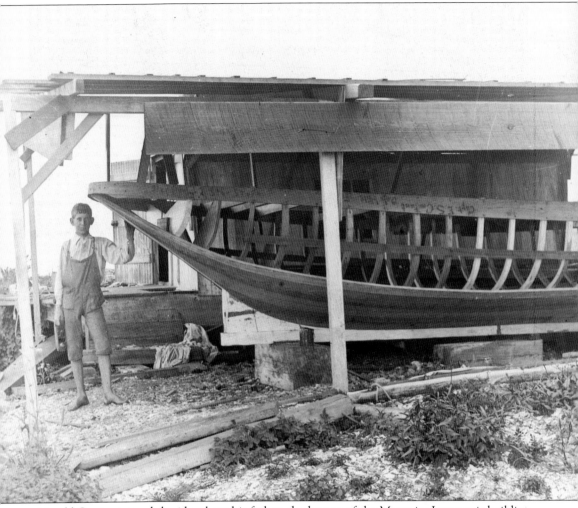

Harold Coutant stands beside a boat his father, the keeper of the Mosquito Lagoon, is building. "Capt. E. S. Coutant Oak Hill, Fla." is burned into the upper plank but appears upside down. The Coutants' nearest post office was across the Mosquito Lagoon at Oak Hill. Since Harold was born in 1890, the photograph was probably taken around 1900. (Historical Society of Martin County.)

Keeper Samuel Coutant (left) takes friends ashore at the foot of Turtle Mound, the largest shell midden on mainland United States. Visible from seven miles at sea, the Indian refuse heap was an important landmark for explorers and mariners before Florida was settled by Europeans. Turtle Mound is about three miles north of where the Mosquito Lagoon House of Refuge once stood. (Sarah Howe Prado.)

This photograph of pioneers standing on a whale was in a Coutant album. It is probably a northern right whale, the most endangered species of whale found off the US coast. From December to March, the whales come to the warm waters off Cape Canaveral to calve and rest. The Mosquito Lagoon House of Refuge once stood in what is today the Canaveral National Seashore. (Elwin Coutant.)

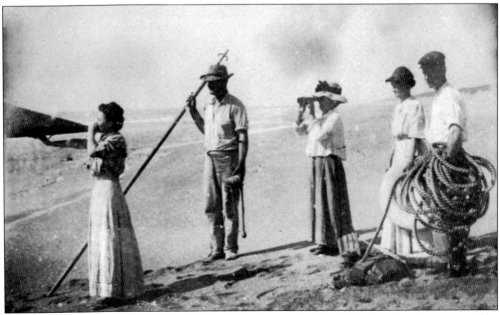

Mosquito Lagoon House of Refuge life-saving equipment is either being used or demonstrated by Samuel Coutant, with boat-hook, and his wife, Louisa, with binoculars. In 1899, the Coutants were forced to watch 12 men from the wrecked ship *General Whitney* drown. Louisa pulled the body of Capt. J.W. Hawthorne out of the water while Keeper Coutant rescued three others who were near exhaustion. (Elwin Coutant.)

A young woman is demonstrating the use of a US Life-Saving Service megaphone. At houses of refuge a megaphone was probably primarily used for hailing vessels and boats along the shore. In 1896, the US Life-Saving Service determined that megaphones were of little use during rescues due to the high noise levels in roaring surf and adverse wind conditions. (Elwin Coutant.)

This young woman certainly is not dressed appropriately for climbing the pole that served as a lookout tower at Mosquito Lagoon House of Refuge. Poles with stepping blocks attached to them appear in early photographs of other houses of refuge and remained standing after 1915 when the US Coast Guard was created. (Elwin Coutant.)

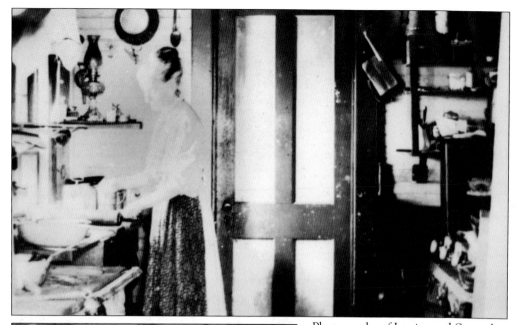

Photographs of Louisa and Samuel Coutant working in the kitchen of the Mosquito Lagoon House of Refuge are priceless and are representative of all other keepers and their wives. The wood-burning stove and utensils give an idea of what life was like. Although the color of the paint cannot be determined, it is evident that the trim was in dark contrast to the walls. (Both, Elwin Coutant.)

This close-up of the dock at Mosquito Lagoon House of Refuge shows the Sabal palm trunks used for pilings. The Sabal palm, commonly called cabbage palm because of its edible heart, is Florida's state tree. Pioneers ate it, used its fronds to thatch roofs, its trunks in construction, and shredded newly emerged fronds to make horse tail–like switches to keep mosquitoes away. (Sarah Howe Prado.)

House of refuge keepers no longer had to depend on water transportation to send shipwreck survivors north after Henry Flagler built his railroad down the east coast of Florida. By 1889, Flagler's system offered service from Jacksonville to Daytona. By 1892, Flagler was laying tracks along Mosquito Lagoon. (Sarah Howe Prado.)

This note written by Samuel Coutant on an official US Life-Saving Service form was kept by his granddaughter. He noted the visit of Ransom and Metta Olds of Oldsmobile fame. Ransom Olds said that the Mosquito Lagoon House of Refuge "was the neatest and best kept station on the Florida coast." (Sarah Howe Prado.)

Jeanette Coutant practices violin on the porch of the Mosquito Lagoon House of Refuge around 1900. A five year old when her father was appointed keeper, she grew to womanhood at the station. Her daughter Sarah Howe Prado preserved photographs and memorabilia from the family's years at Mosquito Lagoon House of Refuge. (Sarah Howe Prado.)

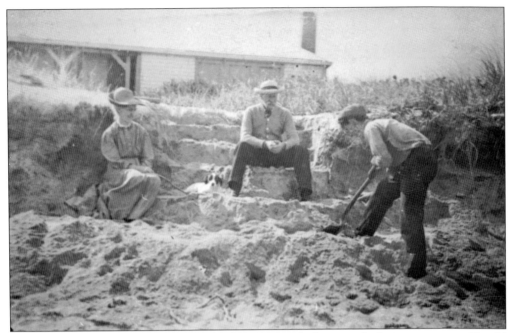

Louisa and Samuel Coutant, accompanied by the family dog, watch their teenage son Harold make steps in the bluff formed by a recent storm. The enlarged kitchen now fills the space that was the northeast end of the porch. (Elwin Coutant.)

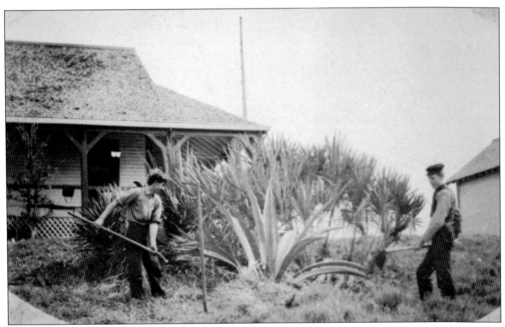

Harold Coutant helps his father, Keeper Samuel Coutant, clear weeds away from the base of an agave, commonly called a century plant. The descendants of these plants are so numerous that they are a nuisance in the Canaveral National Seashore where the Mosquito Lagoon House of Refuge once stood. (Elwin Coutant.)

The three Coutant children grew up at the Mosquito Lagoon House of Refuge. Harold was born in Ormond in May, shortly before the family moved into the station in 1890. Aimee was 13, and Jeanette was 5. Both girls were born in Iowa. This c. 1902 photograph was taken of the Coutant children on the steps of the Mosquito Lagoon House of Refuge. (Elwin Coutant.)

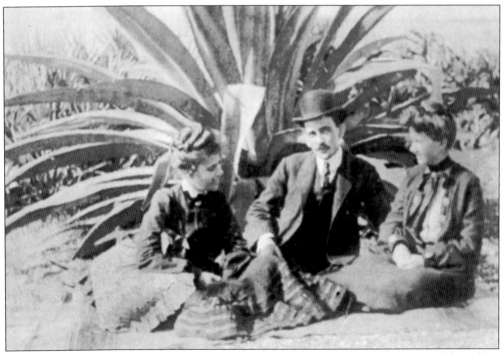

Jeanette Coutant, at left, poses with her older sister Aimee and Aimee's fiancé, Ralph Willits. Aimee and Ralph were married in Mount Gilead, Ohio, in 1906. Their family, including four children—Virginia, Bob, Eleanor, and Dick—moved from Palatka to Stuart in 1924. Century plants, like this one at the Mosquito Lagoon House of Refuge, were the favored backdrop for photographs. (Elwin Coutant.)

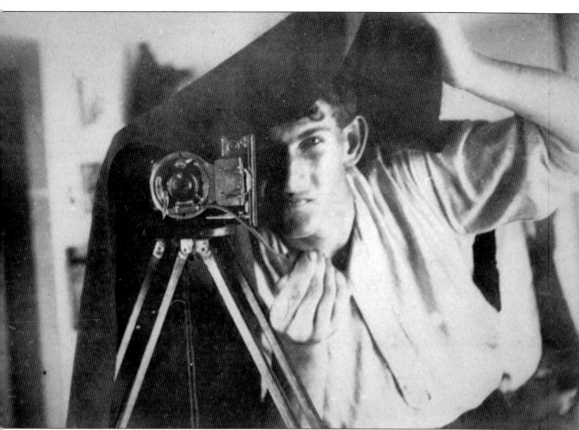

Harold Coutant grew up with photography because his father had a dark room in the Mosquito Lagoon House of Refuge. His real expertise, however, was engine and motor repair. He left the Mosquito Lagoon House of Refuge with his mother's blessing but without his father's knowledge around 1910. After his departure, he worked at Jackson and Gladwin Boat Works in Fort Pierce and later opened the first garage in Stuart because automobiles were growing in popularity. (Elwin Coutant.)

Harold Coutant, reading in the parlor of the Mosquito Lagoon House of Refuge, is a vintage version of today's teenager. An Edison phonograph, with a morning glory horn and a supply of cylinder records, is close by. The masthead of the newspaper the *Florida Star*, published in Titusville from 1880 until 1917, is readable in the light cast by the large oil lamp. (Elwin Coutant.)

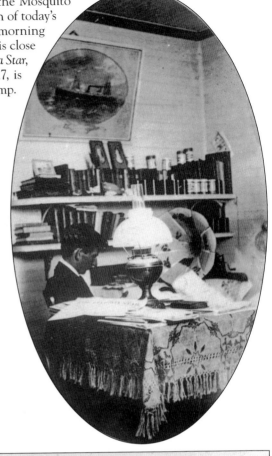

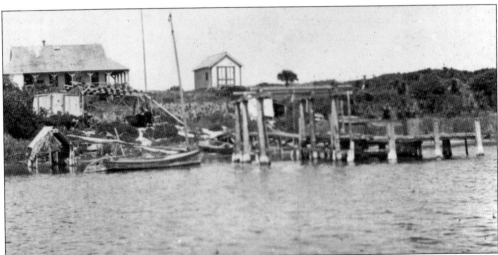

The Mosquito Lagoon waterfront at the house of refuge looks quite cluttered. Perhaps this photograph was taken when Samuel Coutant suffered from "lumbago" and could not bend over to tie his shoes. In a 1960 interview, Harold Coutant said he covered for his father who probably would have lost his job if his illness had become known. (Sarah Howe Prado.)

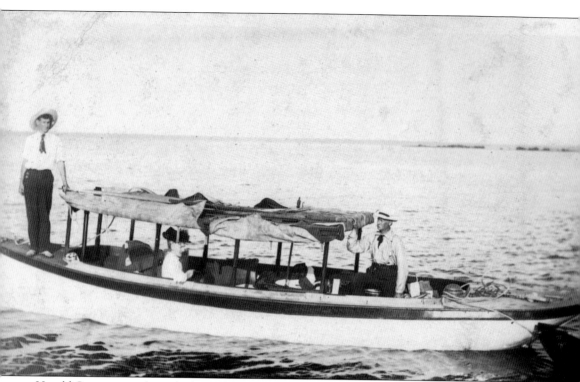

Harold Coutant stands on the bow of the family motor launch during an outing with his parents, Louisa and Samuel Coutant. Harold spent the first 20 years of his life at the Mosquito Lagoon House of Refuge. In a 1961 interview, he told of telling his mother good-bye and hurriedly leaving in a canoe without his father's permission. (Sarah Howe Prado.)

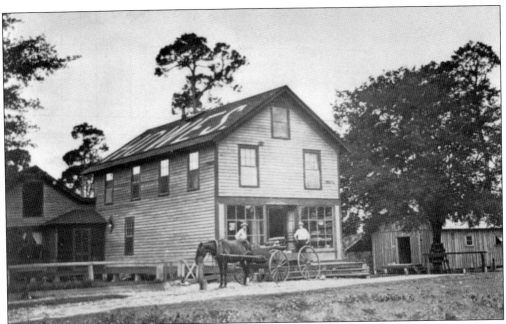

In 1907, Jeanette, the younger Coutant daughter, married William Luther Howes, whose parents owned a general store in Oak Hill across Mosquito Lagoon from the house of refuge. Their youngest child, Sarah Louisa, named after her grandmother, provided many photographs for this publication. (Sarah Howe Prado.)

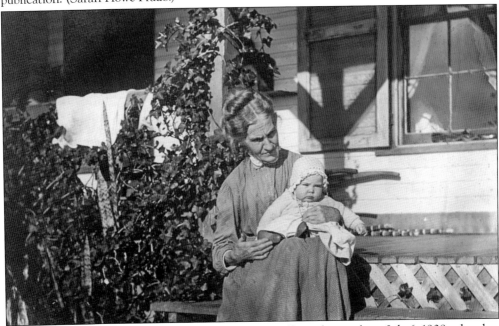

Louisa Coutant holds her first grandchild, Virginia Willits, who was born July 6, 1908, when her parents lived in Indianapolis, Indiana. Virginia moved with her family to Stuart, Florida, in 1914 and graduated from Stuart High School in 1926. The thin-bladed plant within the vine at left is Sanseviera, commonly called Mother-in-Law's Tongue or Snake Plant. It was very popular in pioneer days. (Sarah Howe Prado.)

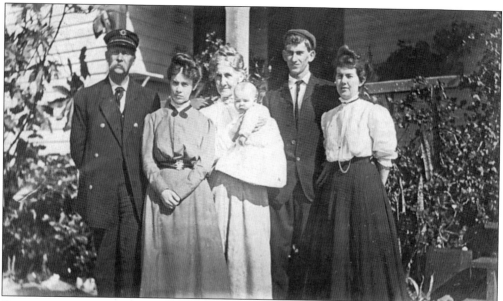

Keeper Samuel Coutant poses with his family around 1909. From left to right are Keeper Coutant, Ethel Coutant Willits, Louisa Coutant (holding her first grandchild, Virginia Willits), Harold Coutant, and Jeanette Coutant. (Sarah Howe Prado.)

This display of craft items made by the Coutants at the Mosquito Lagoon House of Refuge illustrates the family's skills. According to family tradition, Samuel Coutant received photographic training in Rochester, New York. He had a dark room at the house of refuge and taught his son Harold photography. When Samuel retired from the US Life-Saving Service, he set up a printing shop in Stuart, Florida. (Sarah Howe Prado.)

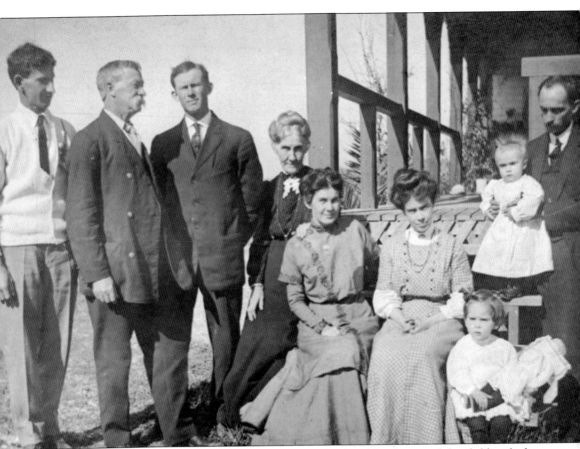

This photograph of the Coutants' growing family can be dated by the age of the child with the spiked hairdo, Ralph C. "Bob" Willits, born October 25, 1909. They are, from left to right, Harold Coutant, Keeper Samuel Coutant, William Howe, Louisa Coutant, Jeanette Coutant Howe, Aimee Coutant Willits, Virginia Willits, and Ralph Willits (holding his son Bob). (Sara Howe Prado.)

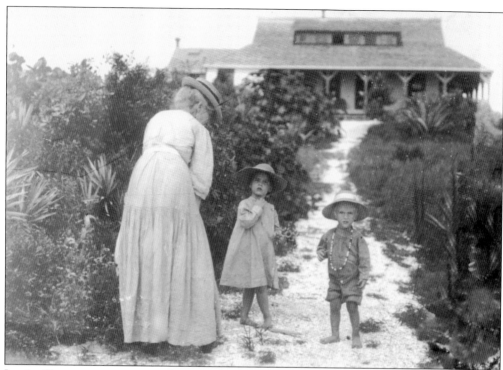

Louisa Coutant is entertaining her grandchildren Virginia and Ralph C. "Bob" Willits at the Mosquito Lagoon House of Refuge. The date of the photograph is probably 1911, judging from the ages of the children. Samuel Coutant retired from the US Life-Saving Service the following year. Note the recently added upper-story bank of windows. (Historical Society of Martin County.)

The Constitution, one of a fleet of so-called "day cruisers" built by the McCoy brothers, Ben and Bill of Holly Hill, passed the Mosquito Lagoon House of Refuge on a regular schedule between Daytona and Palm Beach between 1909 and 1910. Bill McCoy was to gain fame as a rumrunner during Prohibition. His unadulterated fine whiskeys are supposedly the basis of the term "Real McCoy." (Sarah Howe Prado.)

Four

FRED HALL'S
WORLD WAR I–ERA
COAST GUARD IMAGES

Photographs from the family of Fred Hall, who served at US Coast Guard Station No. 207 during World War I, are the only ones of that era available. These photographs provide insight into what training was like at all of Florida's surviving US Life-Saving Service facilities. US Coast Guard Station No. 207 was formerly the Gilbert's Bar House of Refuge.

When the US Coast Guard was created on January 28, 1915, Axel Johansen and his wife, Kate, continued to live in the house of refuge that had been their home for five years. They remained there through November 1918.

Local men were enlisted as temporary Coast Guardsmen at a recruiting station at Sewall's Point, across the Indian River from US Coast Guard Station No. 207. William Leonidus Baker enlisted on April 20, 1917, only 15 days after the United States entered World War I. This is known because there are a number of completed World War I recruitment forms for Coast Guard servicemen in the Florida Archives augmenting other Coast Guard documents in Records Group 26 of the National Archives. These documents, together with Fred Hall's photographs, provide a fairly clear understanding of things as they were in the early days of the US Coast Guard in Florida.

Frederick Leroy Hall was born in Greenville, Pennsylvania, on November 14, 1897. His father purchased land from C.C. Chillingworth and moved the family to Palm City in 1914. In 1924, during the Florida boom, the family purchased land in Stuart, built a house, and subdivided part of their property as Lake Charlotte Subdivision. The lake was named after Hall's mother, Charlotte Hardy Hall.

During World War I, Hall served at US Coast Guard Station No. 207 on Hutchinson Island, not far from his family. He married Ruth May Wiley in 1922 and made his home in Stuart for the rest of his life. He owned Hall's Electric and Appliance Store in downtown Stuart and built the Park Shopping Plaza across from Memorial Park. Hall died May 18, 1964.

Fred and Ruth Hall had one daughter, Susan, who shared the photographs her father took during his time in the US Coast Guard, and Susan's daughter Jennifer Strauss found additional photographs.

Frederick LeRoy "Fred" Hall, who was born in Greenville, Pennsylvania, in 1897, moved to Stuart, Florida, with his parents in 1914. After the United States entered World War I on April 6, 1917, a recruiting station was set up on Sewall's Point, the peninsula across from US Coast Guard Station No. 207. Hall was one of several local boys who signed up for duty in the US Coast Guard. (Jennifer Johnson Strauss.)

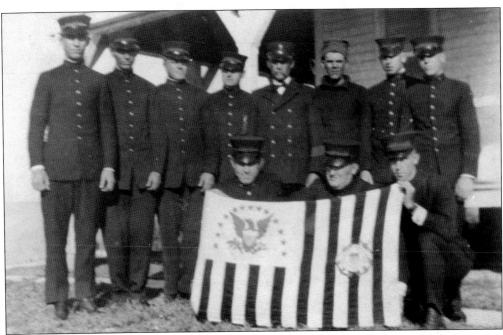

The photographs of Coast Guard training during World War I that Fred Hall and his family preserved are priceless. Hall is second from the right in the back row in this group photograph of the men proudly displaying the US Coast Guard flag. Axel Johansen, center, can be distinguished from his subordinates by the insignia on his cap, the stripes on his sleeve, and the double row of buttons on his service uniform blouse. (Jennifer Johnson Strauss.)

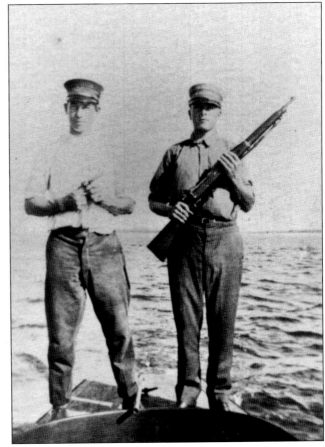

Fred Hall (left) and Lawson Ziegler (right) were among the local boys who augmented Axel Johansen's pre–World War I station crew of five surfmen, which was made up of C.F. Midt and E.W. Evans of Chatham, Massachusetts; F.M. Loy of Council Groves, Kansas; W.L. Baker of Seville, Florida; and J.C. Paterson of Georgia. (Jennifer Johnson Strauss.)

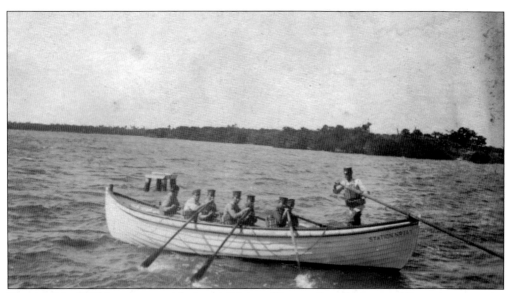

"Station No. 207" is written on the bow of this pulling surfboat being used for training in the Indian River Lagoon. Even Capt. Axel Johansen at the tiller is wearing a life vest, although the men were required to pass strenuous swimming and life-saving tests. The title "Captain" continued to be used as an informal courtesy when former house of refuge keepers became members of the Coast Guard, although their official title was keeper or officer in charge. (Susan Hall Johnson.)

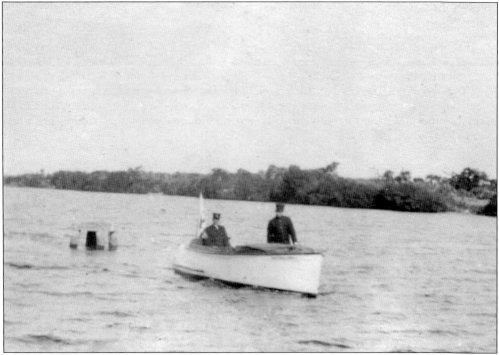

Fred Hall steers US Coast Guard Station No. 207's motor skiff with Capt. Axel Johansen in the stern. A Norwegian victim of shipwreck who was nursed to heath at the Chester Shoal House of Refuge, Johansen returned to Florida, married the keeper's daughter, and spent the rest of his life in the US Life-Saving Service and US Coast Guard. (Susan Hall Johnson.)

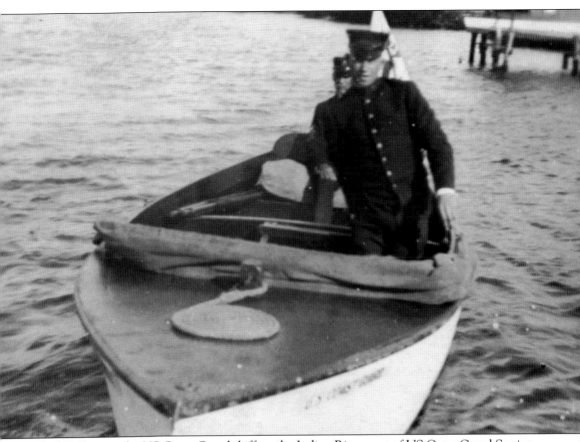

Fred Hall steers the US Coast Guard skiff on the Indian River west of US Coast Guard Station No. 207. According to the July 20, 1917, edition of the *Stuart Messenger*, "The formulas of work to do and how and when to do it in signaling, boat drills, motor boats and pilot rules, resuscitation, storm warnings and 'danger that may arise' keep them wide awake and with one eye open when asleep." (Susan Hall Johnson.)

Fred Hall practices flag signaling at US Coast Guard Station No. 207. He was among the crew members whose families lived locally. Others were Earl J. Ricou, Shelby McCulley, Veril Silva, and Lawson Ziegler. Fay Loy, another member of the crew, moved to the area in 1914, seven years before his family moved from Kansas to join him. Loy's father, Charles M. Loy, became the postmaster of Stuart. (Susan Hall Johnson.)

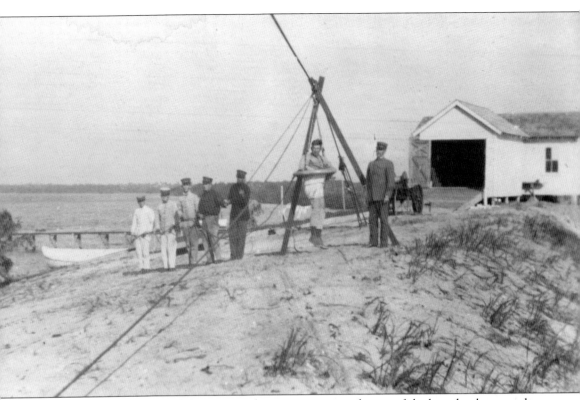

Keeper Axel Johansen (right) supervises his men practicing the use of the breeches buoy on the south side of US Coast Guard Station No. 207. Note there was no road at the time. The long wooden bridge over the Indian River at Jensen, four miles north of the former Gilbert's Bar House of Refuge, was not opened until 1926, and a road to the Coast Guard Station was not completed until 1934. (Susan Hall Johnson.)

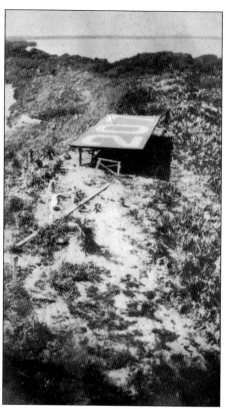

Earl J. Ricou, who served at US Coast Guard Station No. 207 with Fred Hall, preserved this snapshot of the sign placed on the dunes showing the station's number. Each station along the coast displayed its number so it would be visible from the air. The US Coast Guard adjusted to the age of flight before the age of sailing ships was completely a thing of the past. (Chee Chee Ricou Gunsolus.)

Fred Hall included this photograph of a schooner just offshore of the US Coast Guard Station No. 207 in his album. The Anastasia rock formation in the foreground continues to protect the former Gilbert's Bar House of Refuge, the last of 10 houses of refuge that once stood along Florida's east coast. (Jennifer Johnson Strauss.)

Supporting Organizations

One of 10 houses of refuge built along Florida's east coast by the US Life-Saving Service, it is the only one still standing. Gilbert's Bar House of Refuge is owned by Martin County and managed by the Historical Society of Martin County, located in the Elliott Museum.

301 Southeast MacArthur Boulevard
Hutchinson Island
Stuart, Florida 34996
(772) 225-1875
www.houseofrefugefl.org

825 Northeast Ocean Boulevard
Hutchinson Island
Stuart, Florida, 34996
(772) 225-1961
www.elliottmuseum.org

The US Life-Saving Service Heritage Association (USLSSHA) is the national nonprofit historical society dedicated to the history of the US Life-Saving Service and early US Coast Guard, including the preservation and display of relevant equipment, artifacts, and historic structures. Visit www.uslife-savingservice.org for more information.

DISCOVER THOUSANDS OF LOCAL HISTORY BOOKS FEATURING MILLIONS OF VINTAGE IMAGES

Arcadia Publishing, the leading local history publisher in the United States, is committed to making history accessible and meaningful through publishing books that celebrate and preserve the heritage of America's people and places.

Find more books like this at
www.arcadiapublishing.com

Search for your hometown history, your old stomping grounds, and even your favorite sports team.